Picturing America's National Parks

Picturing America's National Parks

Jamie M. Allen

aperture

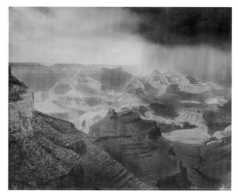

34

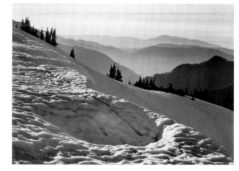

58

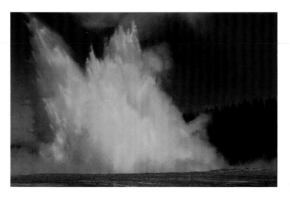

31

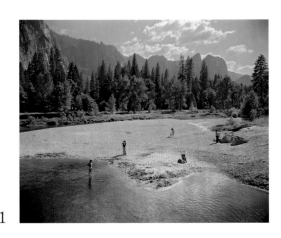
81

98

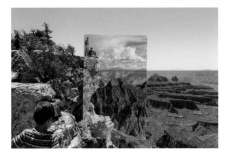
103

109

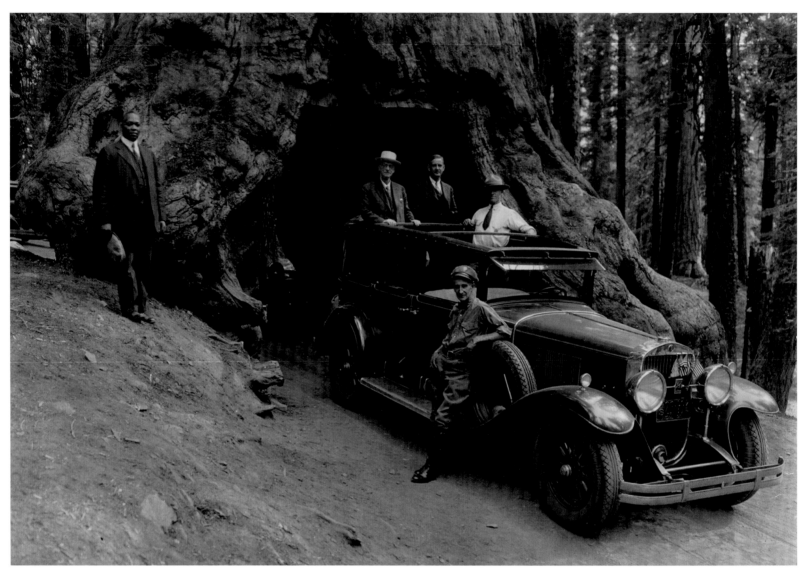

Audley D. Stewart, George Eastman and companions riding through
the Wawona Tree in Yosemite National Park, Pacific coast trip, 1930

Foreword

America's national parks are spaces of natural beauty set aside for the conservation and appreciation of the landscape. As protected sites, they showcase prized wilderness areas, provide places of enjoyment, and allow diverse flora and fauna to flourish. The first such location was Yosemite, which was declared protected land in 1864 by President Abraham Lincoln and became a national park in 1890. In 1916 President Woodrow Wilson signed the National Park Service Organic Act, establishing the National Park Service.

These historic events were made possible through strong advocacy efforts supported by photographs. Many sources indicate that Carleton Watkins's images of Yosemite clinched the argument for granting the land to the state of California, to serve as a place of "public use, resort, and recreation." John Muir, an advocate for the formation of the national parks and founder of the Sierra Club, used copious images in his publication, *Picturesque California* (1888). These and other cases prove that nineteenth-century photographs of the American wilderness were critical to early land conservation efforts.

As we celebrate the centennial of the National Park Service, the George Eastman Museum reflects on photography's role in how we view the parks. The photographs in this book represent more than 150 years of contemplating America's wilderness. They document firsthand the changes that have made the parks accessible to millions of people each year. These images have created standards by which we expect to experience the parks—framing the vistas one cannot miss and simply must photograph during a trip.

An avid traveler himself, George Eastman visited several of the parks, including Yellowstone and Yosemite. His images show him with friends and family as tourists experiencing sites that had been made famous through photography. His views mimic those of many travelers of his time; indeed, this image at Wawona Tree (opposite) offers a subtle indication of other groups waiting to drive through the tree and pose for a similar photograph.

The museum holds one of the foremost photography collections in the world, with more than a thousand photographs depicting various national parks. Varying widely in style and approach, these photographs reveal a range of applications, functioning as documents of major land surveys, souvenirs sold within the parks, artworks that record the parks' grandeur and reflect on the history of photography, and snapshots of private travels.

This book is a companion to *Photography and America's National Parks*, an exhibition drawn predominantly from the George Eastman Museum collection and organized by Jamie M. Allen, associate curator in the Department of Photography. We are grateful to Allen, Lisa Hostetler, and the many museum staff members who contributed to these projects, as well as to Aperture Foundation, our partner in this publication.

Bruce Barnes, PhD
Ron and Donna Fielding Director, George Eastman Museum

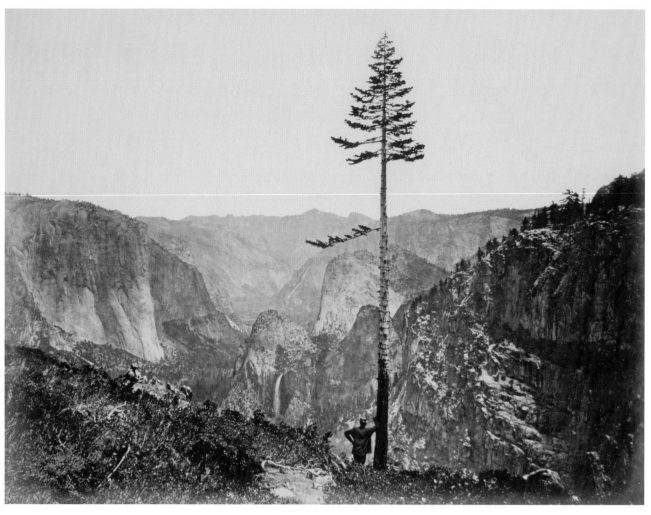

Charles Leander Weed, *Yo-Semite Valley from the Mariposa Trail*, 1863;
from the album *Sun Pictures of the Yo-Semite Valley California*, 1874

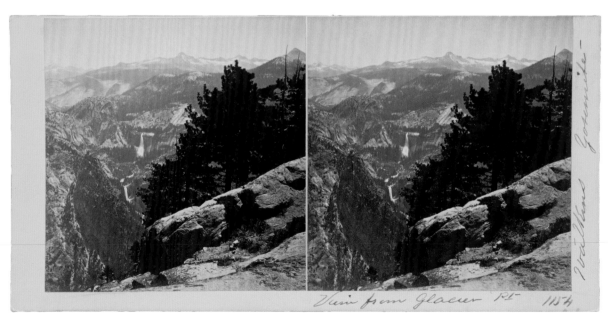

Carleton Watkins, *View from Glacier Pt.*, 1861;
from the series Watkins's Yosemite. Stereograph

Photography and America's National Parks: An Intertwined History

Photography is fluid. Like the relentless power of the Colorado River cutting its way through the Grand Canyon, photography flows from person to person, era to era, and field to field, shaping our perception of the world. The photographs we take today are deeply indebted to those that came before, for somewhere in our modern-day psyche exists a bank of images that undeniably influences how we create new pictures. Nowhere is that more evident than in the legacy of photographs taken within the fifty-nine spaces that we now call America's national parks. These lands were widely explored in the mid-nineteenth century, just after the invention of photography. The medium was quickly employed as a powerful way to capture the immense beauty of unique geological features. Photography made these landscapes known throughout the country and eventually the world, inspiring tourists to visit them and contributing to their status as national symbols. As these areas became increasingly popular, land conservation efforts mounted and photographs were used to lobby for the preservation of these spaces as national parks. And as both the parks and photography equipment became more accessible, tourists began to take their own images, documenting their trips and reiterating the pictures that had drawn them to specific locations. Today we still desire these sublime landscapes, look to images of them for ideal beauty, and seek to visit them in order to take our own pictures. Now in celebration of the centennial of the National Park Service,[1] we trace the symbiotic relationship that the parks and photography have developed over the course of 150 years.

The journey began in the Yosemite Valley in 1859, when Charles Leander Weed arrived on assignment for *Hutchings' California Magazine*. Weed's trip resulted in sixty photographs,[2] twenty of which were rendered as wood engravings so that they could be added as illustrations in the magazine's series "The Great Yo-Semite Valley," which appeared in four installments from October 1859 to March 1860.[3] Although Weed's photographs were among the earliest images of Yosemite ever taken, he remained relatively unknown. In addition to his assignment for *Hutchings'*, Weed was also an employee of Robert H. Vance's photography gallery in San Francisco, which printed and displayed work under the studio name. As such, Weed's work primarily circulated as stereographs for which he was never credited as photographer. These stereographs were sold on the East Coast, but it was Carleton Watkins's photographs taken in 1861 that drew significant national attention to the Yosemite Valley. Watkins had better equipment, including a specially made 18-by-22-inch wet-plate camera equipped with a wide-angle lens.[4] A tireless showman, Watkins displayed the resulting mammoth-plate images across the country while also selling his more affordable stereographs. His photographs became symbols of the American

landscape and established the views that were heralded as the epitome of Yosemite's beauty and grandeur.

Preservationists and legislators used these early photographs by Watkins and Weed as visual support to persuade Congress to protect Yosemite. Prior to the completion of the transcontinental railroad in 1869, travel to the western United States was difficult. Instead of exploring these uncharted territories, most tourists (mainly wealthy, upper-class citizens) went to Europe or more easily accessible destinations such as Niagara Falls. Much like the spaces in the West, Niagara Falls was a place of natural beauty. It had been overrun, however, by an ever-growing tourist industry that required visitors to pay for glimpses of the falls from the most spectacular vantages. Many feared that areas such as Yosemite would suffer the same fate if not set aside as publicly held land. With so few able to directly access the great landscapes of the West, photographic reports were crucial to conservation efforts, providing visual evidence of the majestic nature of these spaces. As a result of such documentation, President Lincoln signed the Yosemite Grant Act in 1864, entrusting Yosemite Valley and the neighboring Mariposa Grove to the state of California for the express purpose of preserving it for public recreation. Through this act, Lincoln and Congress laid the groundwork for the definition of a national park.[5] For Americans, these naturally occurring wonders became destinations equal to the magisterial ruins and cathedrals of Europe.

Due to the limitations of nineteenth-century travel, Yosemite continued to be known in the 1860s primarily through photographs. Indeed these images were in demand on the East Coast, and photographers such as Eadweard Muybridge capitalized on their popularity. Muybridge arrived in Yosemite in 1867, reimagining the views of El Capitan and Yosemite Falls that Watkins and Weed had made famous and adding a new set of spaces to the list. Using a now-standard stereoscopic camera and a 5-by-8-inch camera that produced images in a size that became known as boudoir, Muybridge took photographs that not only document the landscape but also capture the atmosphere of the valley. In particular, he used a printing method that allowed him to add clouds to his images, thus circumventing the technical limitations of a process that could not simultaneously record land and sky. Muybridge would return to the valley in 1872, creating mammoth-plate views similar in size to those that Watkins had produced, and selling subscriptions to his new Yosemite series.

By the 1870s, slews of photographers came to Yosemite during the spring and summer months, mostly to produce easily marketable and popular stereographs depicting the grandeur of the landscape in three dimensions. Several publishers—including Thomas Houseworth and Co.—purchased views from these photographers, which they marketed and sold under their own companies' names.[6] In short, the sale of photographs of the Yosemite Valley was big business. One such photographer came to the valley for a visit but ended up making it his home. George Fiske and his wife became enamored with the valley during a short stay from 1879 to 1881. When they returned permanently in 1883, Fiske had become adept at the new dry-plate process, which allowed him to carry less equipment. Fiske took boudoir-size views as well as 11-by-14-inch imperial-size plates, and he was the first photographer to work there

Eadweard Muybridge, *Ancient Glacier Channel, Lake Tenaya, Sierra Nevada Mountains*, 1872

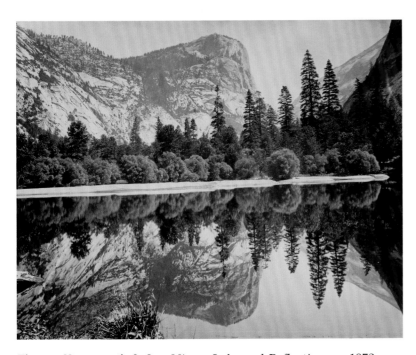

Thomas Houseworth & Co., *Mirror Lake and Reflection*, ca. 1872

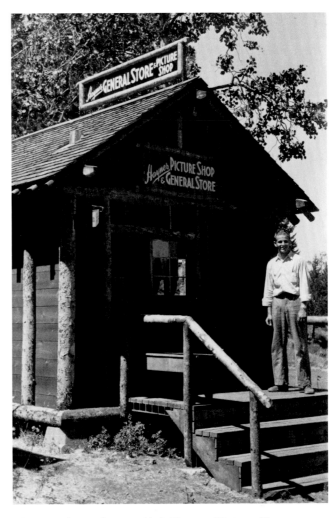

Photographer unknown, *F. J. Haynes Picture Shop & General Store, Yellowstone National Park*, 1930s

11

during the winter months.[7] Conveniently located in the Yosemite Valley, his studio was easily accessible to tourists wishing to purchase his photographs as souvenirs, and Fiske could often be seen making his way through the valley carting his tripod and camera in a wheelbarrow.

By the turn of the twentieth century, several other artists also had studios in the valley, offering not only photographs but also photo-finishing services, paintings, and other goods. Among them was Harry Best, a painter and political cartoonist who came to the valley in 1901. Best eventually set up a studio along with his wife, and each summer they would return to sell artwork produced by them and their family members.[8] In 1920, the family became acquainted with a young man named Ansel Adams, who at the time was the caretaker of the Sierra Club's LeConte Memorial Lodge. Harry's daughter, Virginia, married Adams in 1928; Adams's photographs were then added to the items sold at the store, and the couple took over the business when Virginia inherited it in 1936. (In the 1970s, the studio was renamed the Ansel Adams Gallery; it continues to be run by descendants of Adams.)

From Weed's first views of the valley to Adams's iconic images, Yosemite remains one of the most quintessential landscapes of the American West. The photographs of this space established the untouched wilderness as a unique kind of tourist destination in the United States, and the popularity of the images proved that the model of setting aside land for public enjoyment was profitable. As such, Yosemite's story became the standard for land conservation organizations, and the photographic lineage of many national parks follows a similar trajectory.

As settlers moved West after the Civil War, the funding of government land surveys and the creation of promotional materials for railroad companies prompted a need for more images.[9] Indeed many of the most significant photographers of the time worked on one or more of these projects. Timothy O'Sullivan photographed present-day Arizona, California, Idaho, Nevada, New Mexico, Utah, and Wyoming; William H. Bell recorded areas along the Colorado River; and William Henry Jackson worked in present-day Colorado and Wyoming. Their images were sent back to the East Coast and circulated among members of Congress to help secure further funding. The photographs were also available for sale to the general public. Many wealthy or adventurous individuals saw these views and were prompted by newly built railroads to travel and see the sites for themselves.

In turn, each park developed its own tourist industry, with photographers like Fiske in Yosemite setting up studios to sell their images, take tourists' portraits, and process film for sightseers who had brought their own cameras. Frank Jay Haynes, who became known as the official photographer of Yellowstone, had perhaps the most successful business in a national park. Beginning in 1877, Haynes served as the exclusive photographer for the Northern Pacific Railway, a position that afforded him the opportunity to travel to Yellowstone and make a set of photographs in 1881. Yellowstone had become the first official national park in 1872, largely due to the photographs taken that year by William Henry Jackson as part of Ferdinand Vandeveer Hayden's Geological and Geographical Survey of the Territories. The photographs Haynes made for Northern Pacific

were now more commercially geared to show prospective passengers the wonders of Yellowstone that awaited at the end of their journey.[10] Realizing how many travelers the railroad would bring to the park, Haynes wrote to the Department of the Interior requesting an exclusive lease at Mammoth Hot Springs and the rights to be the sole photographer of that area.[11] The lease was granted and Haynes opened his first photography studio in Yellowstone in 1884, quickly creating photographs of the most significant sites in the park. As Yellowstone's popularity grew, so did business, and Haynes opened more stores throughout the park. By the early 1900s, his son Jack Ellis had joined the family business, and the studio and its products remained a mainstay in the park until 1966.

With the parks gaining the attention of tourists the world over, groups interested in land and wildlife conservation also saw an opportunity to use the same images that had attracted people to these sites. One of the most prominent organizations of this kind was the Sierra Club, which raised awareness for environmental preservation. Involved with the club since 1919, Ansel Adams became one of its most active members. By 1930, he helped organize the club's annual High Trip outings, serving as official trip photographer. In 1934, at the age of thirty-two, he was elected to the board of directors.[12] His images were published in the club bulletin and were used to lobby for making areas such as Kings Canyon into national parks. Adams also created portfolios and books that highlight the club's preservation efforts. One such example, *This Is the American Earth*, featured an exhibition of photographs in 1955, followed by a publication in 1960, both of which introduced the club's mission to a wider audience.[13] As his work became known worldwide, it helped establish the parks as a source of national pride and as international tourist destinations.

Adams was also a member of Group f/64, along with such well-known artists as Imogen Cunningham and Edward Weston. Formed in 1932, the group was dedicated to the creation of "pure" or "straight" photographs. This method strove to separate photography from other fine-art mediums, including painting, instead employing the inherent technological advantages of photography—such as the rendering of contrast, texture, and depth-of-field—to create pictures unaffected by subjective impulses. Embracing images that show the world in sharp focus, many of the Group f/64 photographers worked in areas that were then or are now national parks, including Yosemite, Mount Rainier, and Death Valley. The group published articles and held exhibitions to showcase their photographic vision. In addition, many of the members taught at schools and workshops, influencing future landscape photographers such as Eliot Porter and Philip Hyde.

The national parks were designed to provide the average person with respite from the modern world by facilitating access to natural beauty. By the mid-twentieth century, however, attendance had increased due to many factors, including the creation of the National Park Service, the invention of the automobile, the construction of roadways within the parks, and the rise of tourism. Between the 1930s and 1960s, car culture took hold of the United States, and families began to embark on road trips that often stopped at a

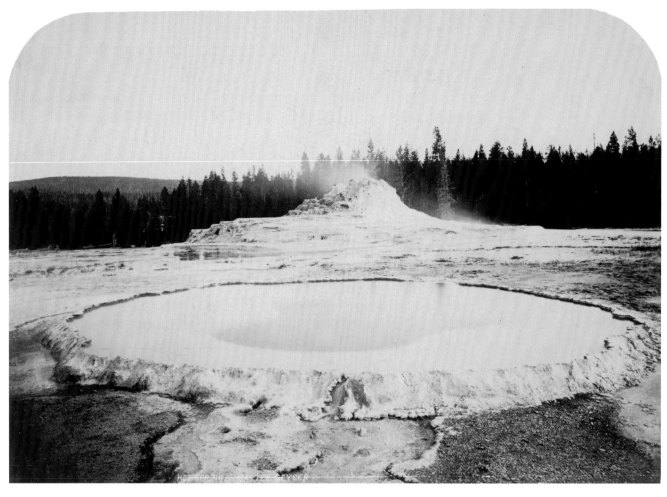

William Henry Jackson, *Hot Spring and Castle Geyser*, 1872

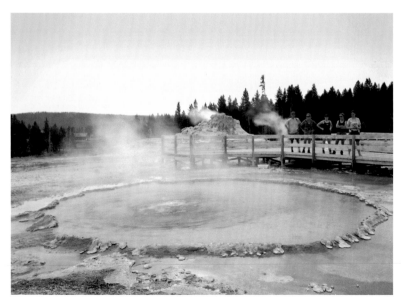

Mark Klett and Gordon Bushaw for the Rephotographic
Survey Project, *Crested Hot Springs and the Castle Geyser,
Yellowstone National Park, Wyoming*, 1978

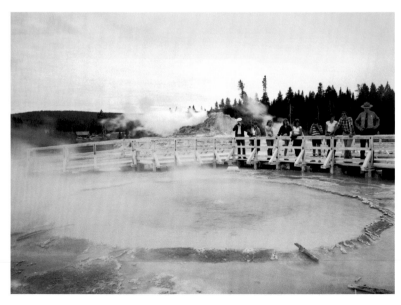

Mark Klett and Gordon Bushaw for the Rephotographic
Survey Project, *Crested Hot Springs and the Castle Geyser,
Yellowstone National Park, Wyoming*, 2000

national park. Americans became passionate about escaping to the landscape, and the parks were affordable destinations for all. Postcards and advertising campaigns thus began to feature the parks, often highlighting the presence of tourists enjoying the view.

Beginning in the 1960s, photographers such as Garry Winogrand, Joel Sternfeld, Stephen Shore, and Roger Minick turned their cameras on these visitors and the human relationship to the landscape. Instead of presenting now-famous views, their photographs reveal how these spaces are consumed. Tourists pose at Old Faithful, gaze into the Grand Canyon, and gawk at a moose across a river. Often introducing subtle critiques, these images call into question our attraction to the landscape, our impact on it, and our ever-growing need to soak in as much nature as we can while on vacation.

With the emergence of postmodernism in art, photographers of the 1970s increasingly turned their attention to the medium itself. Between 1977 and 1979, the Rephotographic Survey Project (RSP), led by Mark Klett, identified the exact locations where over 120 nineteenth-century landscape photographs were made. The purpose of the project was to rephotograph these sites in order to compare their images to the earlier views, noting the evolution of the landscape. Working with images by photographers such as William Henry Jackson and Timothy O'Sullivan, the group drew upon the legacy of these historic pictures and perpetuated the reiteration of specific sites and vistas, including those found at Yellowstone; Shoshone Falls, Idaho; Tenaya Lake, California; and Pyramid Lake, Nevada. In the 1990s, Klett organized a second initiative, called the Third View project. Both RSP and the Third View are accompanied by books, and the latter is also available as a website.[14] These publications serve as reports on the two projects, drawing attention to the lineage of photography in these spaces as well as to how humans have inflicted change on the landscape over the course of a century.

While it might be said that the most recent generation of photographers continues to address themes of social commentary and rephotography, they also bring new elements into the discussion. Many contemporary photographers call into question how we use photography to memorialize our experiences.

One example is the work of Sean McFarland, which oscillates between reality and fiction. What appears to be a beautiful Yosemite landscape of waterfalls is actually three versions of the same image superimposed onto each other in a Polaroid print—a form of instant gratification once used by tourists to produce of-the-moment images free from manipulation. McFarland's process, however, jeopardizes our belief in the veracity of photography. The repetition of the waterfall certainly seems to create a more beautiful scene, but the triad also becomes excessive as each feature competes for our attention, prompting us to wonder if and how the photograph has been manipulated. The image thus highlights our societal desire for more out of our experience of nature.

Over six generations of photographers have mediated our understanding of these natural spaces. While many individuals may not have the ability to travel to all fifty-nine parks, images that impart the beauty and splendor of America's national parks are readily available. Through social media people can share their real-time experiences. We no longer have to physically

travel to a park, as we can have a communal experience on our phones and computers. Photography allows each visitor to make the park his or her own. Like snapshots from a century ago, the images found on platforms such as Instagram and Facebook showcase how these spaces are enjoyed, adding to the ever-growing number of photographs taken in the parks. The massive volume of images draws upon the established views, and adds to our nation's library of documents and memories that display a passion for the bewildering beauty of nature and moments of escape.

The images in this book take us on this journey, from the first mammoth-view photographs of Yosemite to digital images shared through social media. They show us the intertwined histories of photography and America's national parks. Without photography, our understanding of these inherently visual spaces would be limited to descriptive words and artists' renderings. From its inception, photography has often been understood as truth, or pure documentation of the world. Through images of the national parks, photography can concurrently be understood as a filter that encourages our passion for these spaces and perpetuates their iconic status. Over the years, our views of the landscape have undoubtedly been shaped by those that came before. The vistas first captured by nineteenth-century explorers still influence people today who visit the parks to partake in the view themselves. Photography has created what we expect to see and compels us to capture our own memories at these sites. Our experience of the parks is so connected to photography that we cannot escape the feeling of being inside a photograph in some of these iconic places, nor resist taking a picture of it ourselves.

Jamie M. Allen
Associate Curator, George Eastman Museum

1839

Multiple photographic processes are announced to the world, spurred by the announcement of the daguerreotype process to the French Academy of Sciences in Paris.

1859

James Mason Hutchings visits Yosemite with photographer Charles Leander Weed after first visiting the valley in 1855 with a group of tourists.

1860

The California Geological Survey is established under the leadership of Josiah Whitney, who regularly hires photographers as part of the survey team.

1861

Carleton Watkins makes his first photographic expedition to Yosemite Valley.

1864

On June 30, President Abraham Lincoln signs the Yosemite Grant, placing the Yosemite Valley and the nearby Mariposa Grove in the care of the state of California.

1867

Eadweard Muybridge makes his first photographs of Yosemite.

Timothy O'Sullivan joins Clarence King's expedition party for the Geological Exploration of the Fortieth Parallel.

1868

John Muir arrives in Yosemite.

1869

The Transcontinental Railroad is completed.

John Wesley Powell leads the first exploratory party through the Grand Canyon.

1870

Henry Dana Washburn leads the first exploratory party in the Yellowstone area.

1871

As part of the Geological and Geographical Survey of the Territories, Ferdinand Vandeveer Hayden leads an expedition into Yellowstone accompanied by photographer William Henry Jackson.

1872

On March 1, President Ulysses S. Grant signs the bill that makes Yellowstone the first national park.

William Bell photographs the Grand Canyon as part of the Geographical Surveys West of the One Hundredth Meridian led by Lieutenant (later Captain) George Montague Wheeler.

1873

John K. Hillers photographs the Grand Canyon as part of John Wesley Powell's Geographical and Geological Surveys of the Rocky Mountain Region expedition party which is exploring the Colorado River.

1875

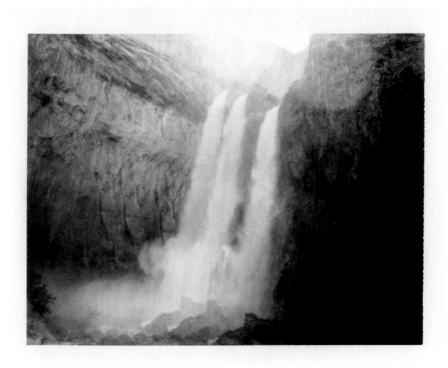

Sean McFarland, *Three Falls, Yosemite*, 2014

1. In 1916 President Wilson signed the National Park Service Organic Act, establishing the National Park Service as an agency of the United States Department of the Interior.

2. According to Gary F. Kurutz, Weed produced "twenty 10-by-14-inch and forty stereographic negatives" during his trip in 1859. See Gary F. Kurutz, "Yosemite on Glass," in *Yosemite: Art of an American Icon*, ed. Amy Scott (Los Angeles: Autry National Center; Berkeley, Calif.: University of California Press, 2006), p. 55.

3. In the original article, only seventeen of the wood engravings are attributed to Weed. See James M. Hutchings, "The Great Yo-Semite Valley," *Hutchings' California Magazine* no. 40 (October 1859): pp. 145–60; no. 41 (November 1859): pp. 192–208; no. 42 (December 1859): pp. 240–52; and no. 45 (March 1860): pp. 385–95. Peter Browning, however, has argued that three additional views are based on Weed's photographs; see Browning's republished edition of James Mason Hutchings, *In the Heart of the Sierras: Yo Semite Valley and the Big Tree Groves*, ed. Peter Browning (Lafayette, Calif.: Great West Books, 1990), pp. 103, 374, and 448.

4. Kurutz, "Yosemite on Glass," p. 61.

5. Yosemite remained under the care of the state until 1890, when it was officially declared a national park. The Yosemite Grant Act predated the first official declaration of a national park: Yellowstone in 1872.

6. These companies occasionally credited the original photographer as well. Kurutz, p. 77.

7. Ibid., p. 81.

8. "Gallery History," The Ansel Adams Gallery, http://www.anseladams.com/gallery-history/ (accessed October 5, 2015).

9. In the United States, the California Geological Survey (established in 1860) was the first scientific survey to use photographs to record the landscapes and geological features it encountered. Josiah Whitney was named state geologist and charged with heading the survey. He hired photographers, most famously Carleton Watkins, as part of the team. After the Civil War, the federal government sponsored four major land surveys in the American West. Two of these surveys were organized under the Department of War: the Geological Exploration of the Fortieth Parallel (est. 1867), led by Clarence King; and the Geographical and Geological Explorations and Surveys West of the One Hundredth Meridian (est. 1869) led by Lieutenant (later Captain) George Montague Wheeler. Photographer Timothy O'Sullivan worked for both surveys, and William H. Bell later replaced him on Wheeler's project. The other two surveys were organized under the Department of the Interior: the Geographical and Geological Survey of the Rocky Mountain Region (est. 1867), led by John Wesley Powell; and the Geological and Geographical Survey of the Territories (est. 1869) led by Ferdinand Vandeveer Hayden. John K. Hillers served as Powell's field photographer, and William Henry Jackson as Hayden's. All of the surveys continued to receive appropriations after field work was completed until 1879, when the United States Geological Survey (USGS) was organized as a government agency dedicated to the classification and examination of public lands and geological features. Many individuals associated with the four major surveys, including some of the photographers, continued their work as part of the USGS.

10. Frank Henry Goodyear, "Constructing a National Landscape: Photography and Tourism in Nineteenth-Century America" (PhD diss., University of Texas, Austin, 1998), pp. 311–12.

11. Ibid., p. 313.

12. "History: Ansel Adams," Sierra Club, http://vault.sierraclub.org/history/ansel-adams/ (accessed October 5, 2015).

13. See Ansel Adams and Nancy Newhall, *This Is the American Earth* (San Francisco: Sierra Club, 1960).

14. See Mark Klett, Ellen Manchester, and JoAnn Verburg. *Second View: The Rephotographic Survey Project* (Albuquerque: University of New Mexico Press, 1984); Mark Klett, *Third Views, Second Sights: A Rephotographic Survey of the American West* (Santa Fe: Museum of New Mexico Press, 2004); and "Third View: A Rephotographic Survey of the American West," http://www.thirdview.org/3v/home/index.html (accessed October 5, 2015).

In 1861, **Carleton Watkins** (American, 1829–1916) traveled to Yosemite to photograph the valley and the giant sequoia trees of Mariposa Grove. Equipped with a custom-made 18-by-22-inch wet-plate camera and a stereoscopic camera, he carried enough glass plates and chemistry to create thirty mammoth-plate negatives and about one hundred stereograph negatives. In Charles B. Turrill's 1918 book on Watkins, he noted that "at least twelve mules were required to pack the outfit of the indomitable photographer" from his studio to Yosemite, and that five mules were needed to carry his equipment around the valley, with one mule dedicated to his darkroom tent alone. Watkins's images of Yosemite became known across the country, and portfolios of his work were sent to politicians who lobbied for the preservation of these lands. As a result, President Lincoln signed the Yosemite Grant Act in 1864, setting aside these lands for the enjoyment of U.S. citizens. Watkins continued to travel to Yosemite throughout the 1860s and 1870s, creating images that established the vantages still used today—including a view of El Capitan that highlights the monolith's stunning verticality.

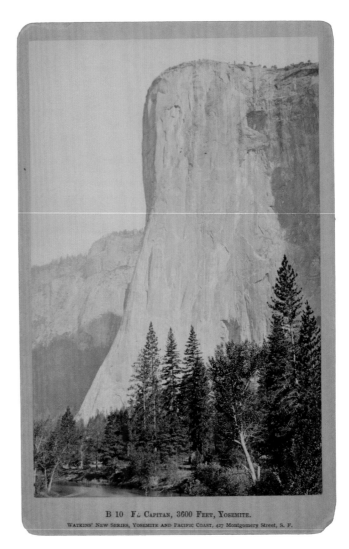

Carleton Watkins, *El Capitan, 3600 Feet, Yosemite*, 1870. Boudoir card

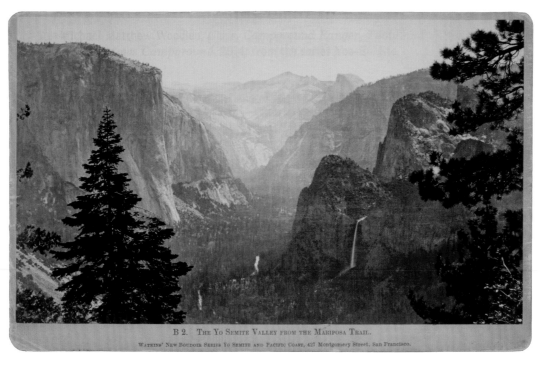

Carleton Watkins, *The Yo Semite Valley from the Mariposa Trail*, ca. 1876. Boudoir card

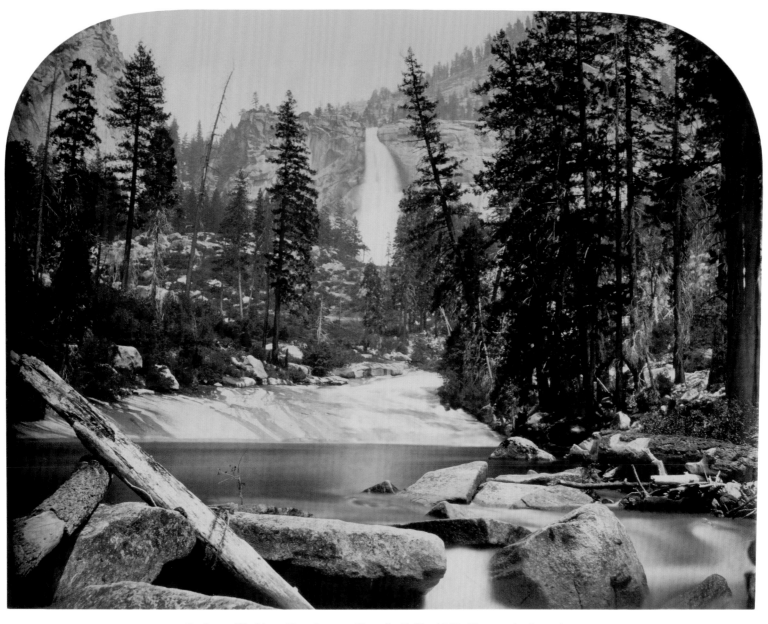

Carleton Watkins, *Yo-wi-ye or Nevada Falls*, 1861. Mammoth plate view

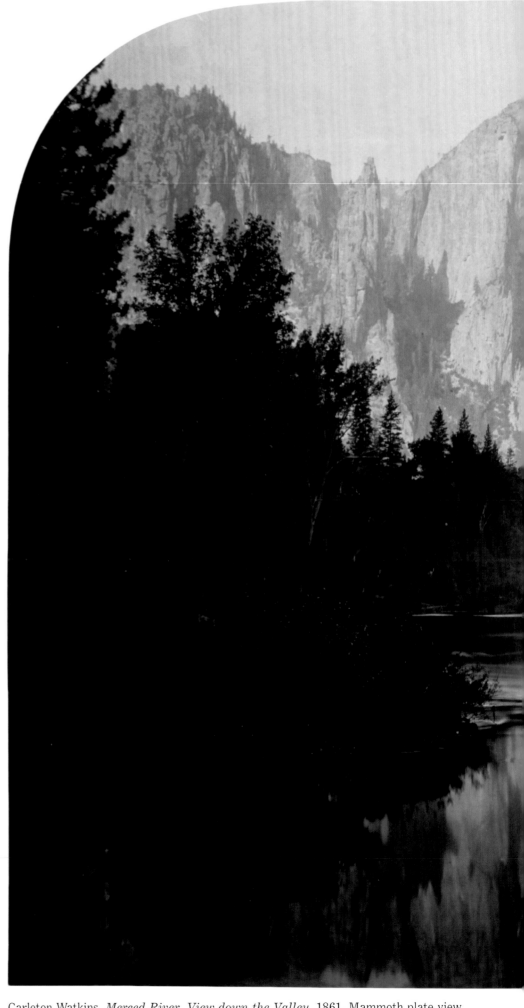

Carleton Watkins, *Merced River, View down the Valley*, 1861. Mammoth plate view

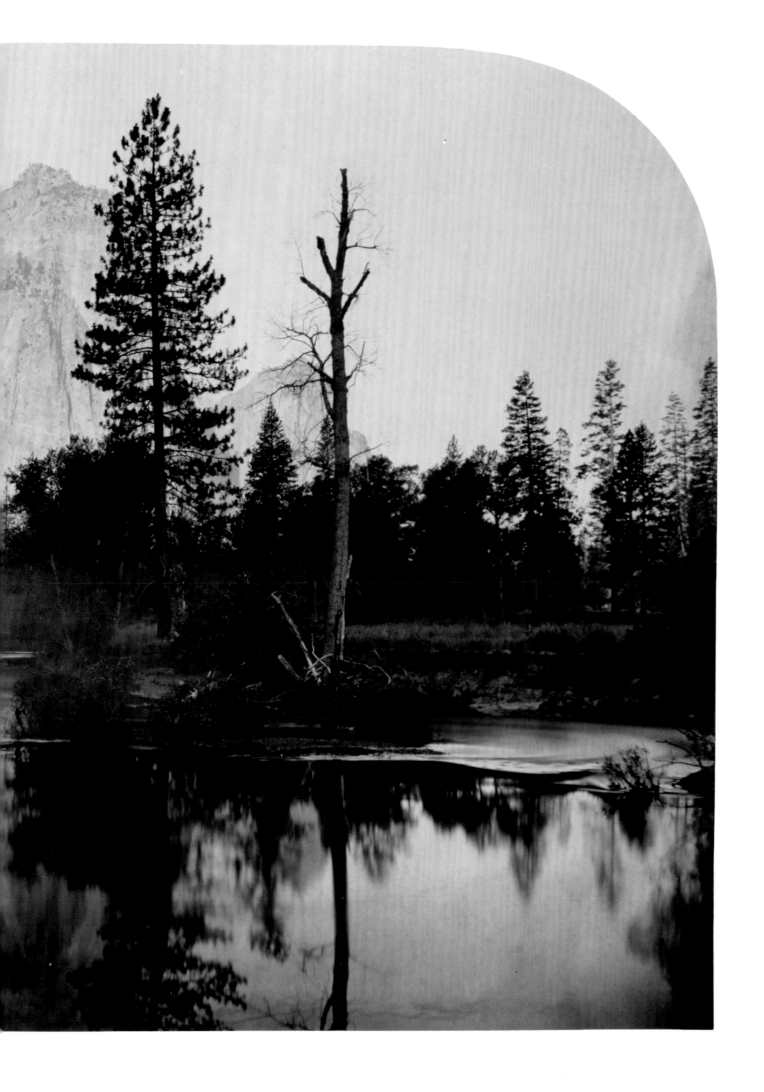

Eadweard Muybridge, *Mount Hoffman, Sierra Nevada Mountains, from Lake Tenaya*, 1872. Mammoth plate view

Perhaps best known for his series exploring animal locomotion with photography, **Eadweard Muybridge** (English, 1830–1904) photographed the Yosemite Valley early in his photographic career. In 1867, Muybridge was well-established in the printing and publishing circles of San Francisco. That year he set up his own photography studio and made his first images of the Yosemite Valley, creating both stereographs and boudoir-size views (about 5 1/2 by 8 1/2 inches). While some of his photographs repeat views that had been established by Charles Leander Weed and Carleton Watkins, Muybridge mostly looked for new vantage points that emphasized the drama of the sweeping valley. During his career, he also became known as a master at creating atmospheric views populated with spectacular cloudy skies—a feature that the wet-collodion could not record concurrently with the landscape and thus had to be added in later. Muybridge's images were one style of photograph among many that were published and sold to the public as photography of the Western American landscape became a booming business, with competing distributors.

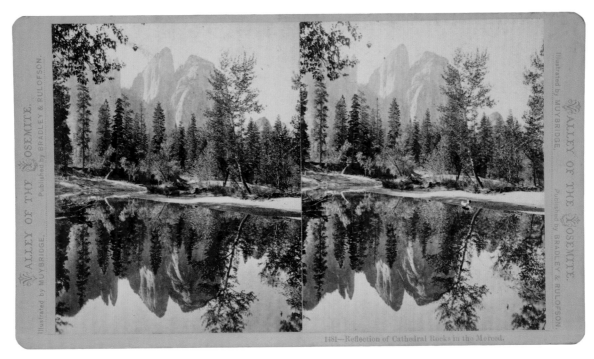

Eadweard Muybridge, *Reflections of Cathedral Rocks in the Merced*, 1872;
from the series Valley of the Yosemite. Stereograph

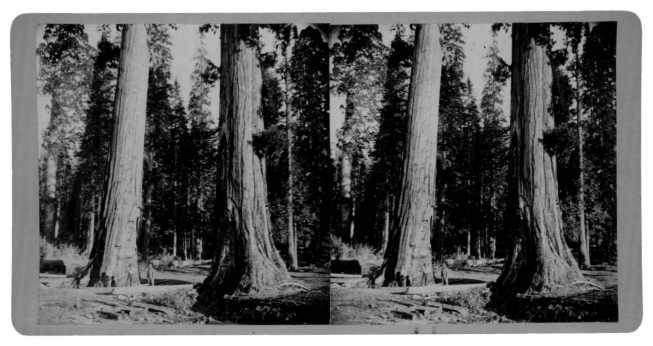

Eadweard Muybridge, *The Sentinels 300 ft. High 69" in Circumference*, 1872;
from the series Views in the Yosemite Valley, California, and Alaska. Stereograph

During the nineteenth century, a series of land surveys allowed uncharted areas of the American West to be mapped, unknown resources to be inventoried, and geological structures to be sketched and later photographed. It was through these expeditions that many of the regions that would become national parks were first imaged, creating a record of these natural spaces as they existed before westward expansion. Between 1869 and 1879, the explorer and cartographer George Montague Wheeler played an influential role in these efforts. In 1872 the U.S. government enlisted him to lead the Geographical Surveys West of the One Hundredth Meridian. Wheeler asked **William Bell** (American, b. England, 1830–1910), who at the time was working for the Army Medical Museum, to serve as the photographer on his team. Bell's vision of the landscape emphasizes dramatic vertical images in which geologic formations become geometric structures neatly stacked in space. His unique perspectives, like the view from underneath an overhang along the Colorado River, capture the monumentality of the canyons that Wheeler's party explored. Used as scientific documents, Bell's photographs were translated into engravings for the survey's official reports. High-end albumen prints were also created and sent to government officials who could bolster support for additional funding for future expeditions.

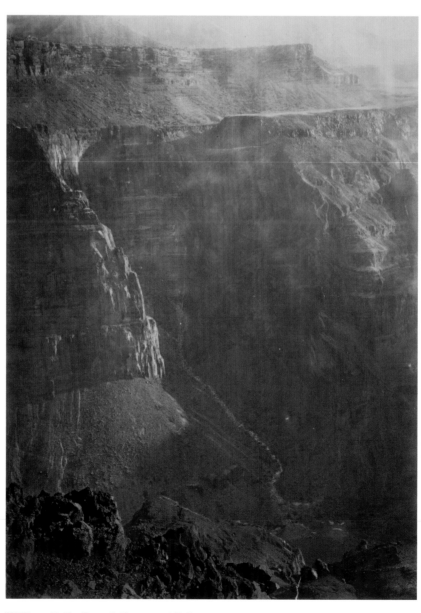

William Bell, *Grand Canyon*, 1872

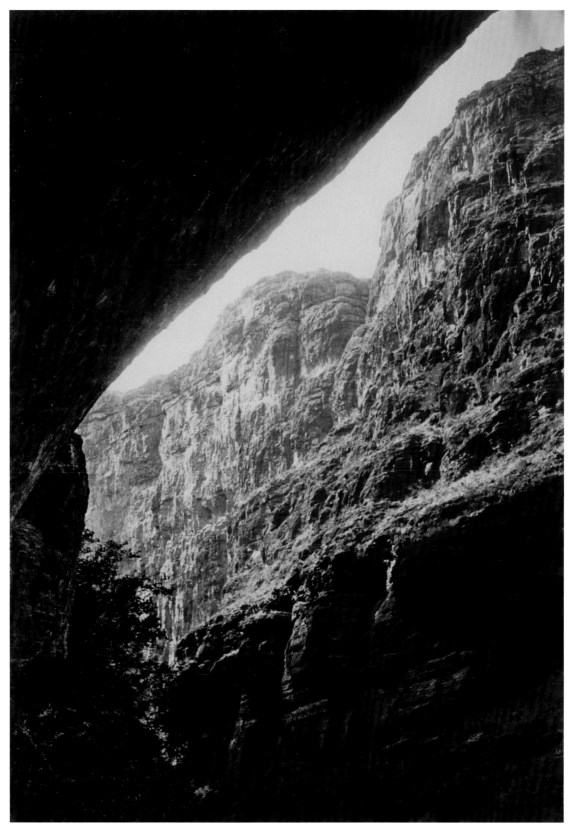

William Bell, *Cañon of Kanab Wash, Looking South,* 1872;
from the Colorado River series

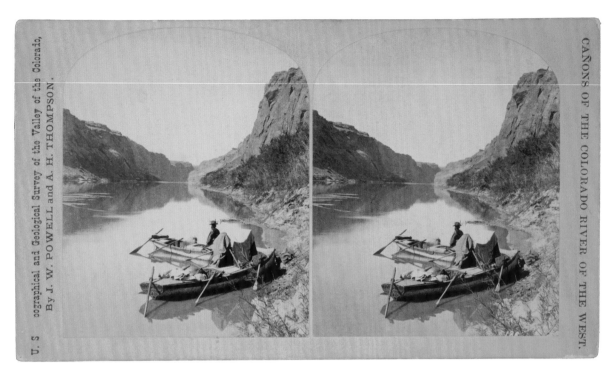

John K. Hillers, Photographer with boats and equipment, 1873;
from the series Cañons of the Colorado River of the West. Stereograph

In 1871, **John K. Hillers** (American, 1843–1925) joined the explorer John Wesley Powell's team for the Geographical and Geological Survey of the Rocky Mountain Region. Originally hired as a boatman, Hillers soon began to assist the photographers, and, by the next year, Hillers became the expedition's chief photographer. Like William Henry Jackson, Hillers worked alongside other artists who sketched and painted the landscape. In 1873, Thomas Moran was invited to accompany Powell's trip to the Grand Canyon region after having gained acclaim for his large-scale painting *The Grand Canyon of the Yellowstone*, which helped establish the area as a national park.

To capitalize on Moran's celebrity and to bring attention to the expedition's efforts, Powell had Hillers photograph Moran working at many of the sites along the rim. Hillers also made photographs that document the unique landscape, many of which served as sketches for Moran's painting *The Chasm of the Colorado* (1873–74). Both Hillers and Moran made images intended to be used to lobby for the preservation of this area. The effects of their work, however, were not as immediate as those in Yellowstone; it was not until some twenty years later that the Grand Canyon was set aside as preserved land, and it did not officially became a national park until 1919.

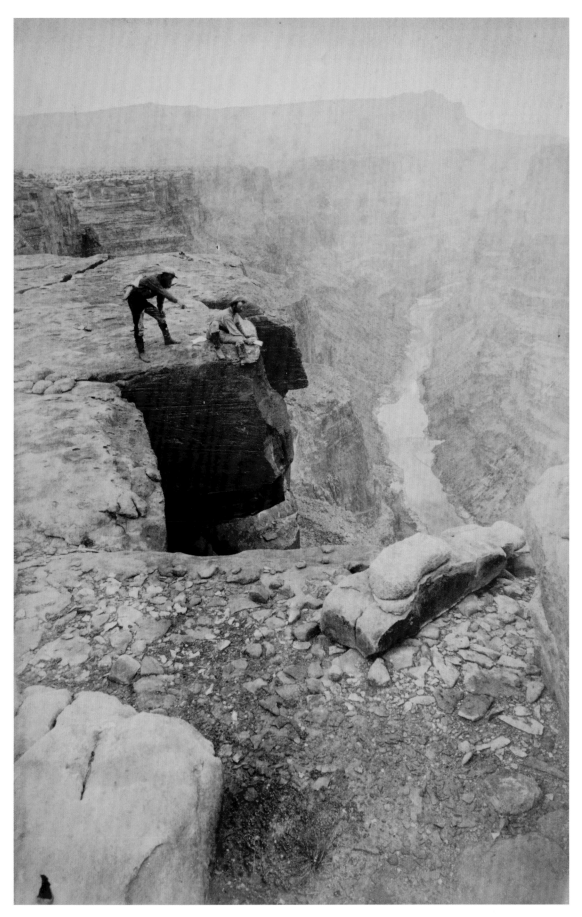

John K. Hillers, *Thomas Moran—Standing Figure—Grand Cañon of the Colorado River, North Rim of the Cañon*, 1873

In 1870, the geologist Ferdinand Vandeveer Hayden invited **William Henry Jackson** (American, 1843–1942) to be the photographer for the Geological and Geographical Survey of the Territories, a federal land survey that would include the Grand Tetons and what would become Yellowstone National Park. Jackson's views of these landscapes emphasize singular natural phenomenon, such as Old Faithful, Mammoth Hot Springs, and the Great Falls (now known as Lower Falls) that lead to the Grand Canyon of Yellowstone. During his trip, Jackson collaborated with the American landscape painter Thomas Moran. The two worked together to select views that highlighted the various features of the land. Jackson photographed each subject and Moran employed watercolors to record the natural hues that photography could not capture at that time. The resulting images do not romanticize or monumentalize the landscape but instead show its picturesque qualities. Jackson's photographs were used alongside Moran's monumental painting *The Grand Canyon of the Yellowstone* (1872) to bolster efforts to preserve this unique landscape as a national park. As a result, the park was established in 1872, and the enduring legacy of the features Jackson photographed continue to draw tourists to the park today.

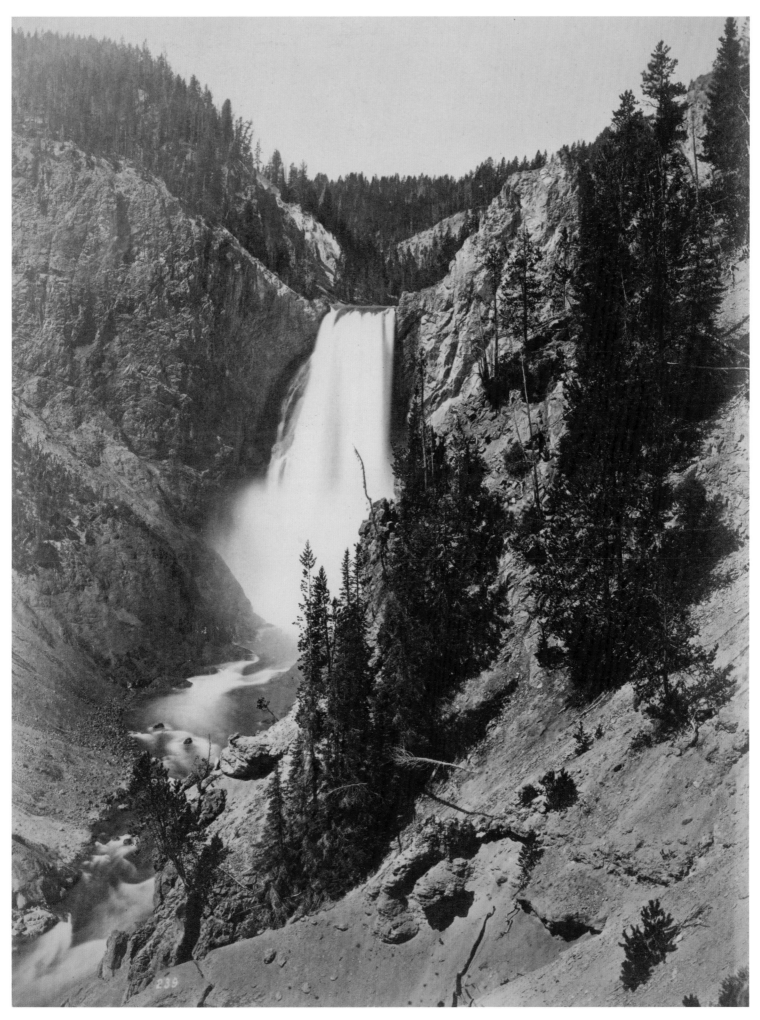

William Henry Jackson, *Lower Falls of the Yellowstone*, 1871

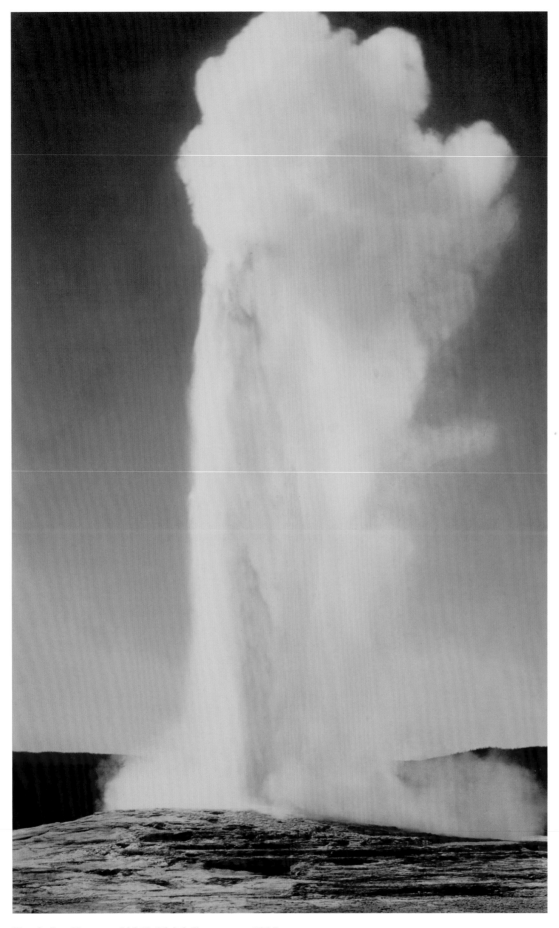

Frank Jay Haynes, *Old Faithful Geyser*, ca. 1900

Frank Jay Haynes (American, 1853–1921, often called F. Jay Haynes) began photographing Yellowstone National Park in 1881. With the knowledge that the park was increasingly a draw for tourists and that the railroads were making it easier for travelers to access it, he photographed views made popular by geological expeditions. His images were so favored by tourists that he was able to expand his business to multiple locations within the park, and he soon became known as its "official" photographer. Although this was most likely a self-granted title, Haynes was also the official photographer of the Northern Pacific Railway. This position allowed him to purchase his own Pullman car, which he outfitted with a photography studio.

The Haynes Palace Studio Car ran from 1885 until 1905, giving Haynes access to the views along the railroad, which he copyrighted and sold under his own name. Additionally, he provided publicity images to Yellowstone National Park that were used to entice more tourists to take the train there. Haynes also pioneered other uses of his photographs, including the manufacture of postcard views in 1897 and as illustrations in *The Haynes Guidebook to Yellowstone*, which was issued annually from 1890 to 1966. In 1916 Haynes retired, transferring his business to his son Jack Ellis, who continued to create postcards until the 1940s and oversaw the production of the guidebook until his death in 1962.

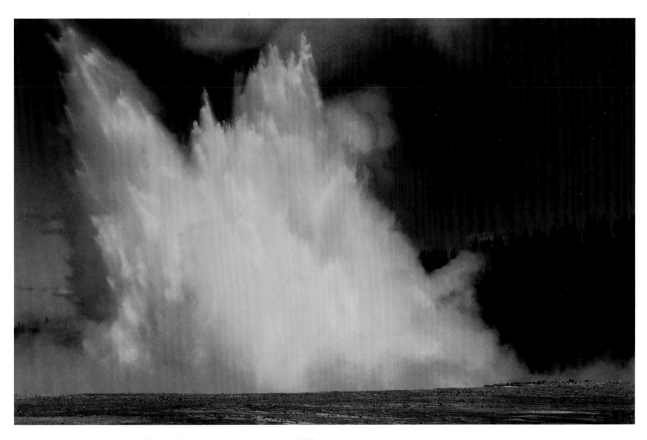

Frank Jay Haynes, *Excelsior Geyser in Eruption*, 1888

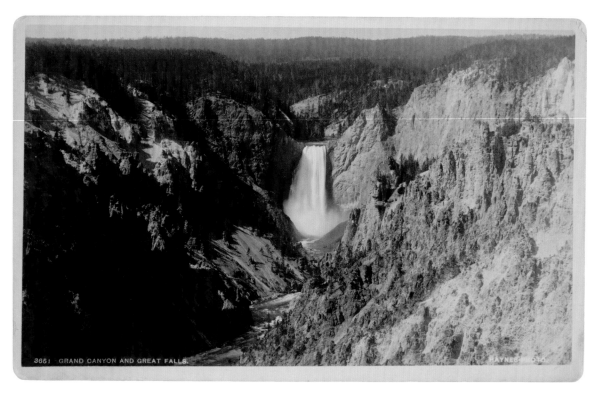

Frank Jay Haynes, *Grand Canyon and Great Falls*, ca. 1881. Boudoir card

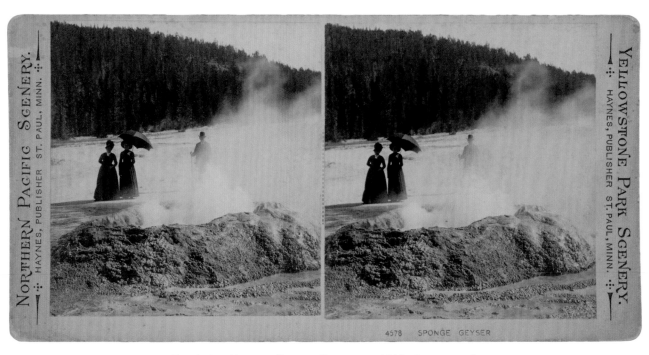

Frank Jay Haynes, *Sponge Geyser*, ca. 1883. Stereograph

1876

1879

John Muir visits Glacier Bay in the Alaska Territory.

The United States Geological Survey (USGS) was organized as a government agency dedicated to the classification and examination of public lands and geological features, and to the evaluation of mineral and other natural resources found on those public lands.

1881

Frank Jay Haynes makes his first photographs in Yellowstone National Park.

1883

The Northern Pacific Railroad is completed, allowing tourists better travel to Yellowstone National Park.

1888

Eastman Company introduces the Kodak camera, an amateur hand camera designed to use Eastman's American Film.

James M. Hutchings's book *In the Heart of the Sierras: Yo Semite Valley and the Big Tree Groves* is published, including engravings derived from photographs of the valley.

1885–1915

Pictorialism, a photography movement that promoted photography as art, becomes popular. The images are often characterized by painterly manipulations and aesthetic expression.

1892

John Muir and a group of Californians form the Sierra Club.

1890

Yosemite and Sequoia are established as national parks.

1899

Mount Rainier National Park is established.

1902

Crater Lake National Park is established.

1903

Wind Cave National Park is established.

1906

Mesa Verde National Park is established.

1907

Tourist postcards become popular when the divided back is introduced, allowing for a message to be written on the left half of the address side of the card.

1913

Congress approves a project to build the O'Shaughnessy Dam in the Hetch Hetchy Valley (part of Yosemite National Park) in order to create a water reservoir for the city of San Francisco and the surrounding area.

1911–12

Alvin Langdon Coburn visits and photographs Yosemite and the Grand Canyon.

1910

Glacier National Park is established.

1914

Ellsworth Kolb's book *Through the Grand Canyon from Wyoming to Mexico* is published, chronicling his and his brother's trip down the Colorado River.

1915

Rocky Mountain National Park is established.

1916

On August 25, the National Park Service is established when President Woodrow Wilson signs the Organic Act.

Haleakalā, Hawaii Volcanoes, and Lassen Volcanic are established as national parks.

1917

Stephen T. Mather named head of the National Park Service.

Mount McKinley National Park (now called Denali National Park) is established.

1919

Ansel Adams becomes custodian of the Sierra Club's LeConte Memorial Lodge in Yosemite National Park.

After previously being declared national monuments, the Grand Canyon and Acadia are officially designated as national parks.

Zion National Park is established.

1920

National parks attendance reaches one million visitors per year.

1921

Hot Springs National Park is established

1926

Congress authorizes the creation of Great Smoky Mountain National Park. As a result, many families who live on this land are asked to relocate and the park is not officially established until 1934.

1928

Bryce Canyon National Park is established.

1929

Grand Teton National Park is established.

1930

Carlsbad Caverns National Park is established.

1930

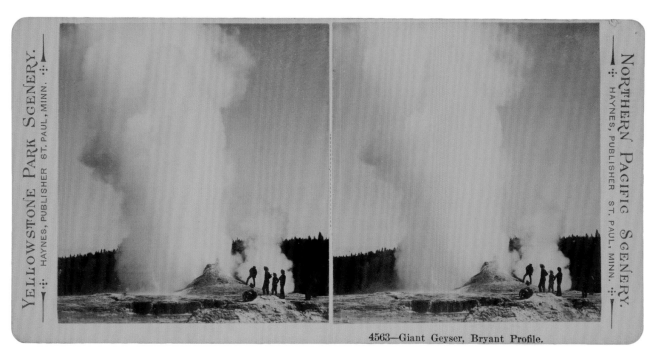

Frank Jay Haynes, *Giant Geyser, Bryant Profile*, ca. 1900. Stereograph

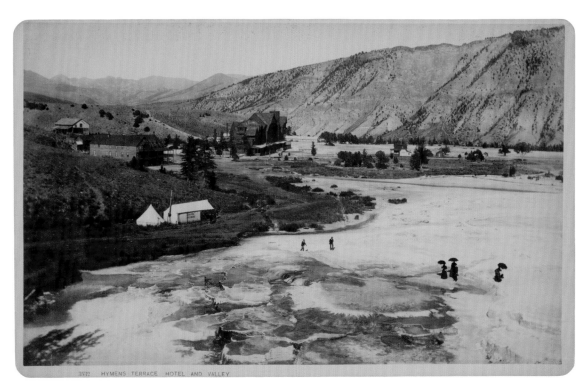

Frank Jay Haynes, *Hymens Terrace Hotel and Valley*, ca. 1890. Boudoir card

Similar to Frank Jay Haynes, **Ellsworth and Emery Kolb** established a photography business at one of America's most prominent natural landmarks. Choosing to settle at the Grand Canyon, the brothers established Kolb Studio on the South Rim in 1904, perched at the top of the Bright Angel Trail, which was and continues to be the canyon's most popular path for casual tourists. At the time, most visitors would ride mules along the steep, 4.5-mile descent to Indian Garden. Although some tourists had their own snapshot cameras, the brothers still profited by taking photographs of the travelers as they began their ride. Emery would then run ahead of the tourists to the darkroom the brothers had set up farther down the trail, where they had access to fresh water and could develop the negatives. He then would head back to the top of the trail so that by the time the group arrived at the studio, he was waiting to sell the freshly printed images. The quality and immediacy of the photographs combined with the novelty of the experience led many to purchase the prints. The Kolb brothers also gained recognition for making the first motion picture to document people traveling down the Colorado River. The film recorded their own 1911 journey, fraught with the excitement of white water rapids, and was shown at the Grand Canyon with Emery's narration until his death in 1976.

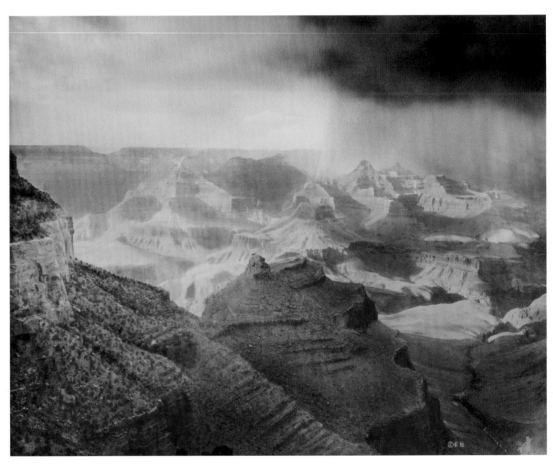

Kolb Brothers, *Overlooking the Canyon from the Head of Bright Angel Trail*, 1913; from the book *The Grand Canyon of Arizona*, 1913

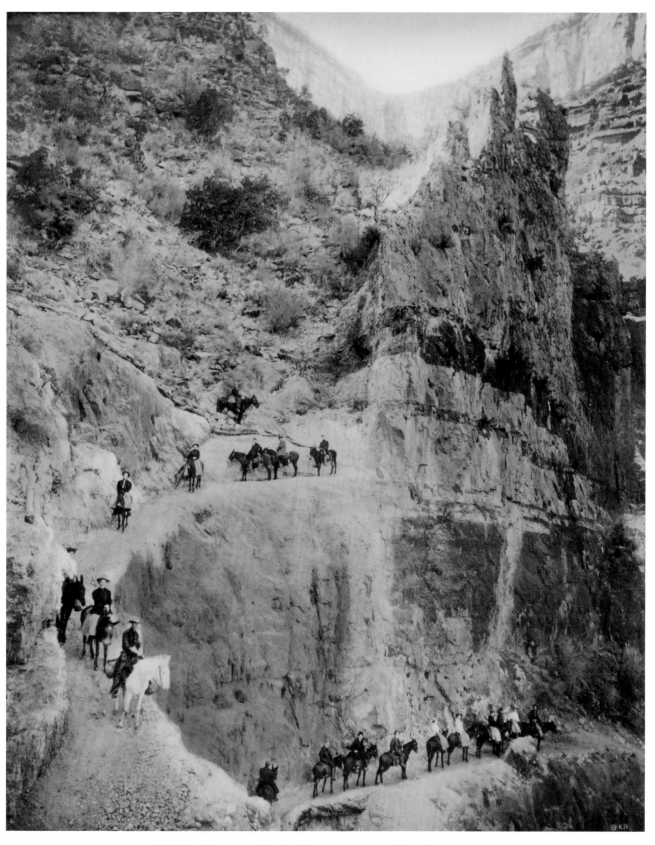

Kolb Brothers, *Jacob's Ladder, 2255 Feet Below the Rim,* 1913;
from the book *The Grand Canyon of Arizona,* 1913

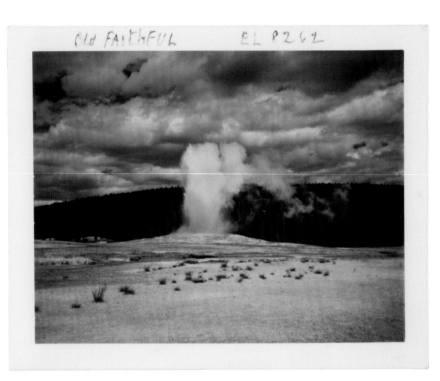

Photographer unknown, Old Faithful Geyser,
Yellowstone National Park, ca. 1968

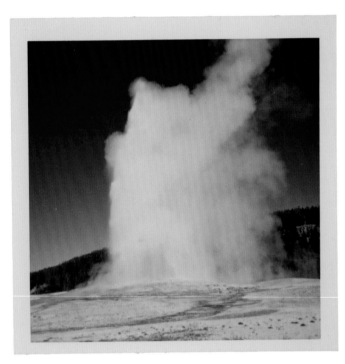

Photographer unknown, Old Faithful Geyser,
Yellowstone National Park, October 1966

With the introduction of the Kodak camera in 1888, photography became available to the general public, and it was estimated that within ten years 1.5 million snapshot cameras had been purchased. By 1900, several of the areas that are now national parks were already established as tourist sites, with must-see locations and vantages that were well-known through published images and stereographs. The first snapshot cameras did not have a viewfinder, so users simply pointed the camera at the subject. Additionally, the images were not readily available to the user, as the entire device had to be sent back to Kodak, which developed and printed the photographs and loaded the camera with new film. With the lack of instant tangible objects that could be shared with family and friends immediately after a trip, visitors continued to purchase images available in the gift shops. By the 1920s, many of the parks had created photographs that mimicked the look of popular snapshots, allowing patrons to place their own images into albums alongside professional views. The true innovation of snapshot photography, however, was the opportunity to personalize images. People could now include loved ones at a well-known site, recording their experience and capturing a memory. This group of snapshots demonstrates the shared experience of images taken over the course of more than eighty years at the same location: Old Faithful at Yellowstone National Park.

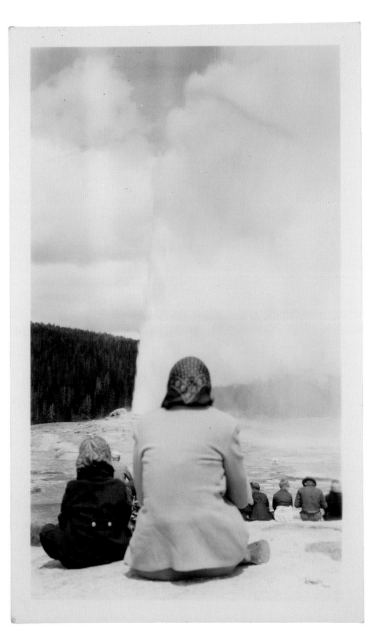

Photographer unknown, Old Faithful Geyser,
Yellowstone National Park, June 1940

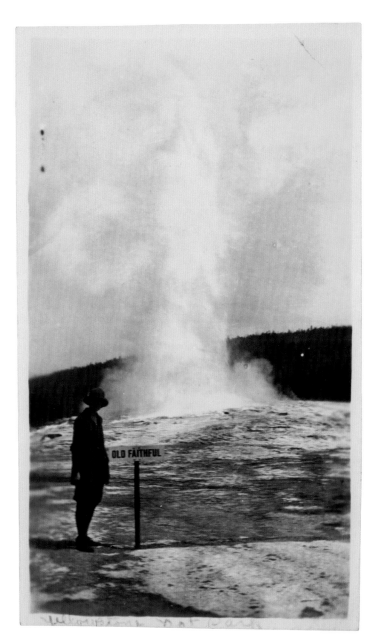

Photographer unknown, Old Faithful Geyser,
Yellowstone National Park, ca. 1915

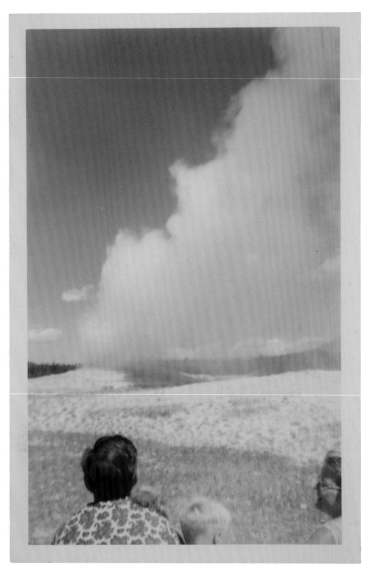

Photographer unknown, Old Faithful Geyser,
Yellowstone National Park, August 1968

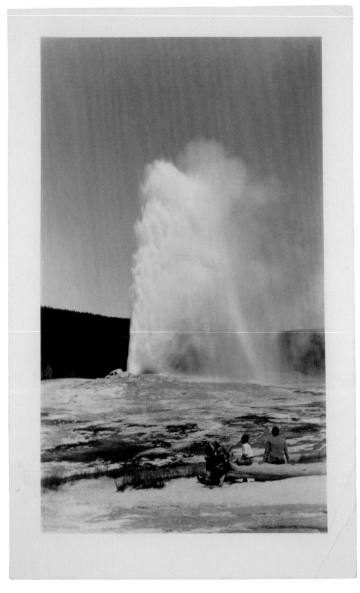

Photographer unknown, Old Faithful Geyser,
Yellowstone National Park, ca. 1940

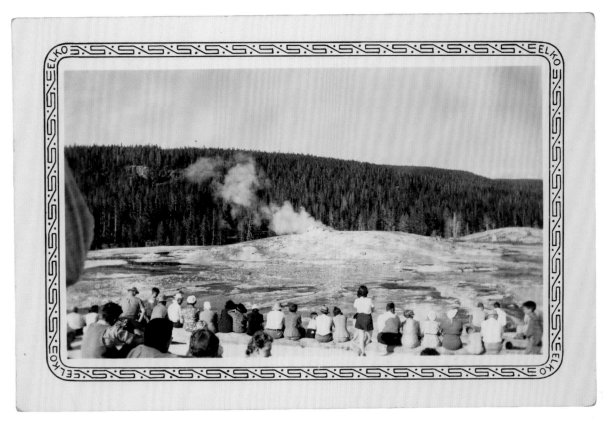

Photographer unknown, Old Faithful Geyser, Yellowstone National Park, ca. 1940

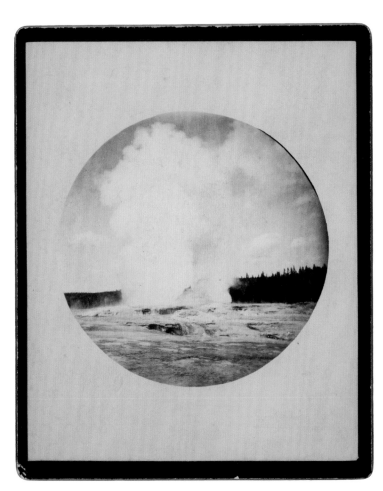

Photographer unknown, Old Faithful Geyser,
Yellowstone National Park, ca. 1895

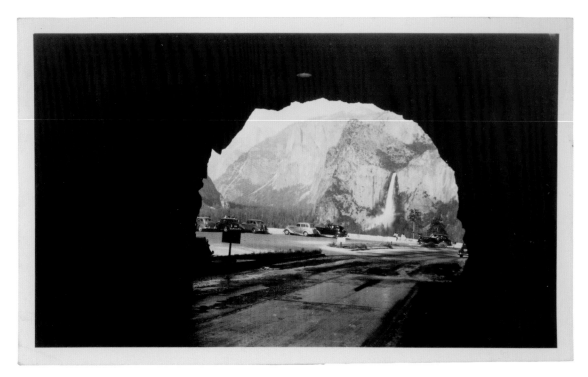

Photographer unknown, Yosemite Valley from tunnel view, ca. 1945

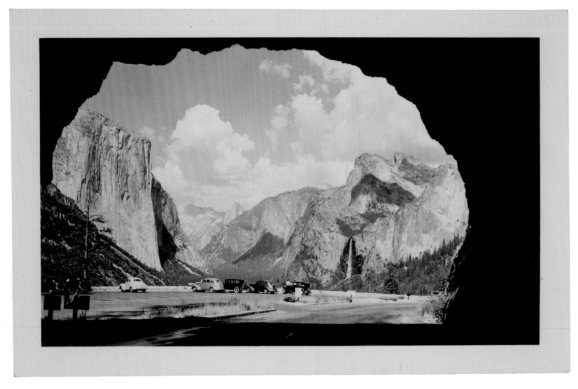

Photographer unknown, Yosemite Valley from tunnel view, ca. 1940

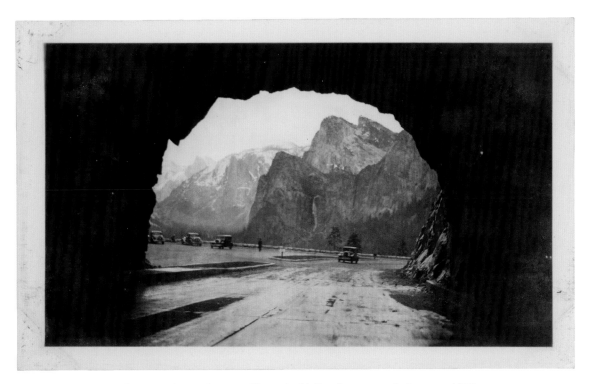

Photographer unknown, Yosemite Valley from tunnel view, ca. 1920

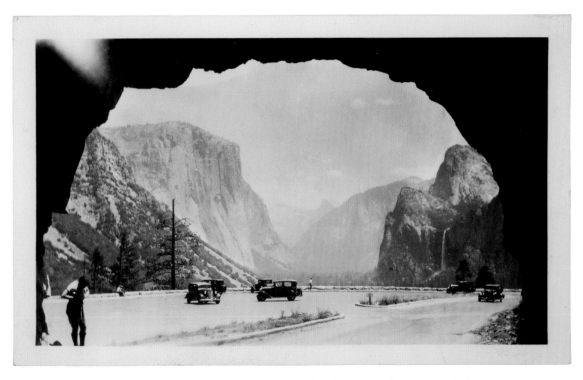

Photographer unknown, Yosemite Valley from tunnel view, ca. 1930

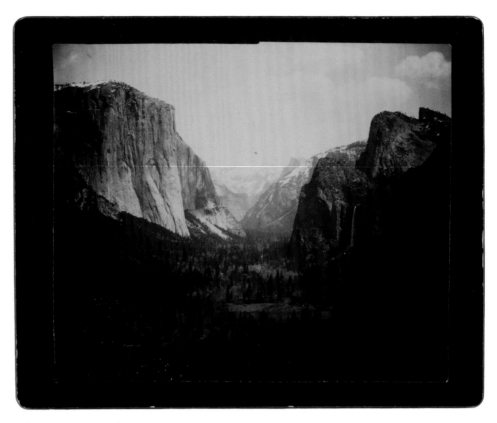

Albert B. Eastwood, *From Artist Point (Yosemite Valley)*, ca. 1895

Photographer unknown, El Capitan as seen through open top of sightseeing bus, ca. 1950

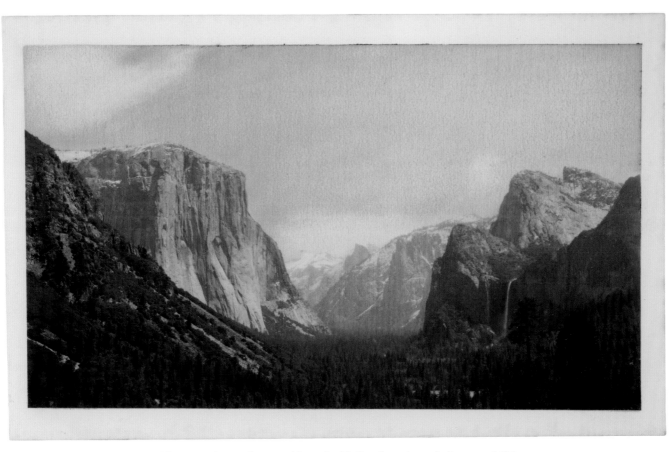

Photographer unknown, Yosemite Valley from tunnel view, ca. 1930

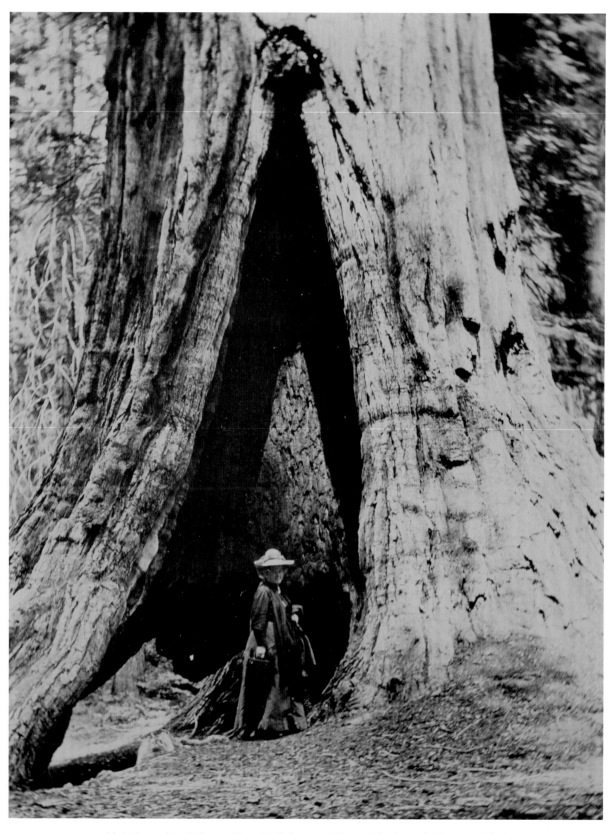

Alvin Langdon Coburn, *Fannie Coburn at Base of Redwood Tree*, ca. 1911

In 1911 and 1912, **Alvin Langdon Coburn** (British, b. United States, 1882–1966) spent about a year traveling and photographing the western United States along with his mother and the artist Arthur Wesley Dow. Their trip took them to the Grand Canyon, as well as Yosemite and Sequoia National Parks. Coburn's photographs from this period show the influence of the Pictorialist movement, during which photographers sought to have their work recognized as art, setting them apart from the numerous snapshots that were being created by the public at large. To help elevate their images to the level of the fine arts of painting and drawing, photographers used processes that required the maker to brush the photographic medium onto the paper, such as gum bichromate or platinum prints. This practice emphasized the hand of the artist. In particular, Coburn often used exaggerated brushstrokes or heavy retouching that are visible in the final print. Pictorialists also drew inspiration from painters such as James McNeill Whistler or from Japanese woodblock prints. Following in this tradition, Coburn often employed flattened spatial compositions or unexpected foreground elements, such as the silhouetted tree branches that frame the Three Brothers rock in Yosemite. While Coburn's artistic work during this time can be classified as Pictorialist, he also produced his own snapshots, such as the image of his mother under a redwood tree.

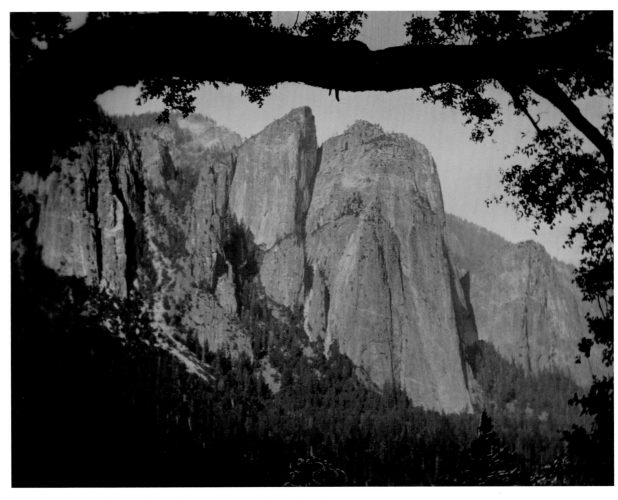

Alvin Langdon Coburn, *The Three Brothers, Yosemite*, 1911

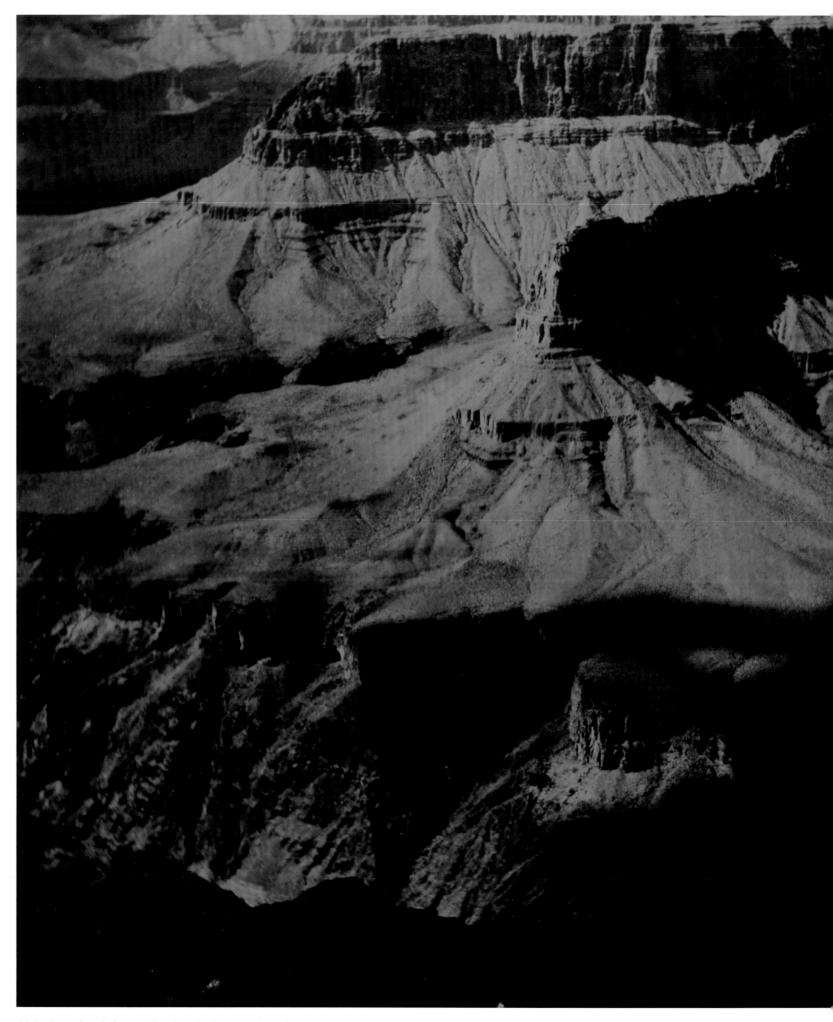

Alvin Langdon Coburn, *The Amphitheatre, Grand Canyon*, 1912

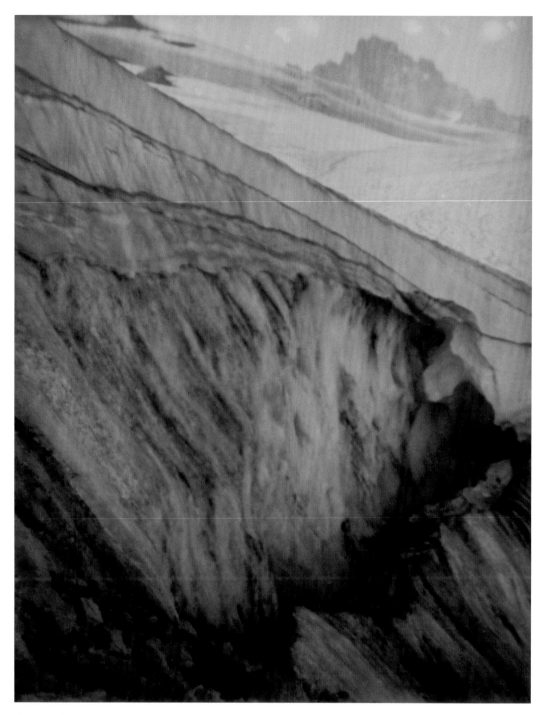

Imogen Cunningham, *On Mt. Rainier*, 1915

Born and raised in the Pacific Northwest, **Imogen Cunningham** (American, 1883–1976) lived and worked in Seattle early in her career. The proximity to Mount Rainier led her to photograph various subjects there, including nude studies and allegorical scenes. *On Mt. Rainier* shows the influence of the Pictorialist movement, including her use of the platinum process and an intense flattening of space drawn from the compositional style of Japanese woodblock prints. Here Cunningham filled three-quarters of the frame with the face of a glacier, setting Mount Rainier—the main subject—off in a distant corner. Her almost complete abstraction of the subject foreshadows her turn toward modernism, which is epitomized by the sharp-focus images of Group f/64, a collective of West Coast–based photographers that Cunningham helped to found in 1932.

1932

Ansel Adams, Imogen Cunningham, and Edward Weston start Group f/64 to promote "straight" photography.

1933

President Franklin D. Roosevelt reorganizes several government offices, assigning historic monuments and parks that were under the care of the War Department and Forest Service to the National Parks Service.

1934

Eastman Kodak Company's German division, Kodak AG, introduces the Retina Model 117, the first Kodak 35 mm camera, and with it the industry standard 35 mm film magazine.

Great Smoky Mountains National Park is established.

1935

Shenandoah National Park established.

1937

Edward Weston becomes the first photographer to receive a Guggenheim Fellowship.

1938

Olympic National Park is established.

1940

Isle Royale and Kings Canyon are established as national parks.

1941

Ansel Adams is hired to photograph the national parks.

Over 21 million people visit the national parks this year.

Mammoth Cave National Park is established.

1944

Big Bend National Park is established.

1946

Eastman Kodak Company introduces Ektachrome, a color transparency film that can be home-processed.

1947

Henri Cartier-Bresson, Robert Capa, David Seymour and George Rodger establish Magnum Photos.

Everglades National Park is established.

1948

First Polaroid Land Camera is sold, allowing users to instantly see their photographs.

Photographer Bradford Washburn and his wife Barbara are filmed for an RKO Radio Pictures documentary as they climb Mount McKinley (now called Denali) in Alaska.

1950

Ansel Adams releases Portfolio Two: The National Parks & Monuments, which includes fifteen photographs.

Kodak begins to advertise at Grand Central Station in New York with 18-by-60-foot color transparencies known as Coloramas.

1955

Approximately 62 million people visit the national parks this year.

1956

Virgin Islands National Park is established.

1960

The Sierra Club releases the first book in its Exhibit Format series, *This Is the American Earth*.

1960

Johan Hagemeyer (American, b. Netherlands, 1884–1962) learned many of his photographic skills from Edward Weston, with whom he shared a close friendship. Despite his straight-forward modernist style of photography, similar to the work of many in Group f/64, Hagemeyer opted not to join the group when Weston, Cunningham, and others formed it in 1932. He did not want to be influenced by or compared to others in the group. Hagemeyer later became known primarily for his portraits of artists and intellectuals, but he did photograph industrial and natural landscapes throughout his career, including this image, most likely taken in the Badwater Basin area of Death Valley National Park—the lowest point of elevation in the United States.

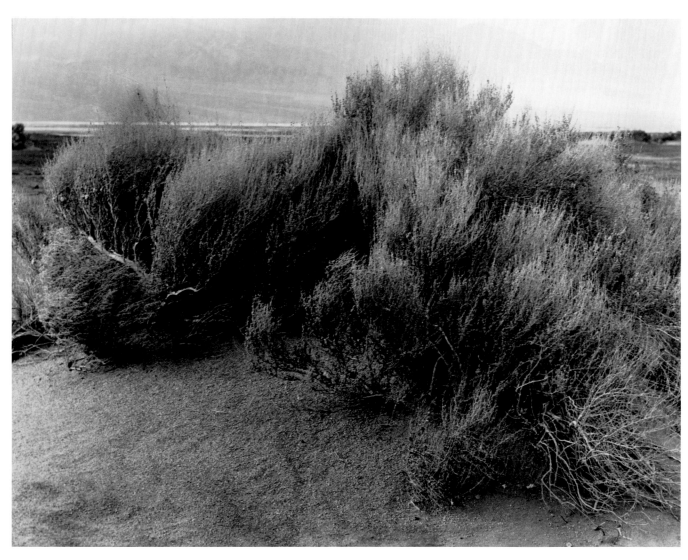

Johan Hagemeyer, *Bad Waters, Death Valley*, 1940

As cars became more readily available in the early twentieth century, the national parks were suddenly accessible to a broader audience. This new mode of transportation, however, required something from the landscape: the construction of roads, parking lots, and campsites, as well as pavement to cover the dirt paths and make the ride smooth and enjoyable. The introduction of the car also created a new kind of tourism. Suddenly the road trip as epic journey became a mainstay for family vacations, with the parks as attainable destinations along the route. In the 1920s, as the national parks ramped up their promotions to help draw tourists who could now travel to the parks by car, several publishers in partnership with hotels created postcards of the most popular sites in the parks. By this point, these locales were well-established through stereographs, publications, and the onset of snapshot photography. Other postcards illustrate the comforts of the parks, including hotels with scenic views, beautiful dining rooms, and newly paved roads.

By the 1930s, most postcards were made using photomechanical processes, such as photolithography. These techniques allowed for the image to be based on a photograph but also gave publishers the ability to add colors to the image. In an era of black-and-white photography, the colors added to the sense of wonder that awaited visitors to the park.

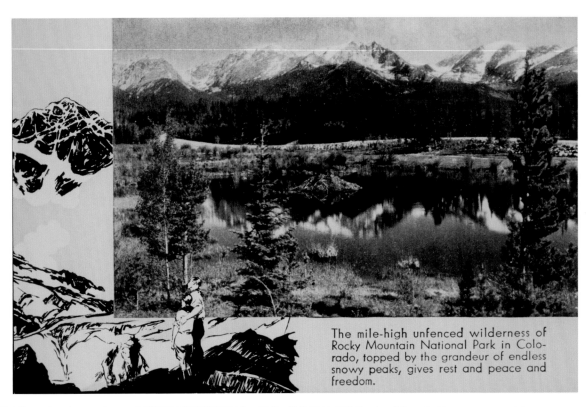

The mile-high unfenced wilderness of Rocky Mountain National Park in Colorado, topped by the grandeur of endless snowy peaks, gives rest and peace and freedom.

Photographer unknown, *The mile-high unfenced wilderness of Rocky Mountain National Park in Colorado, topped by the grandeur of endless snowy peaks, gives rest and peace and freedom*, ca. 1950

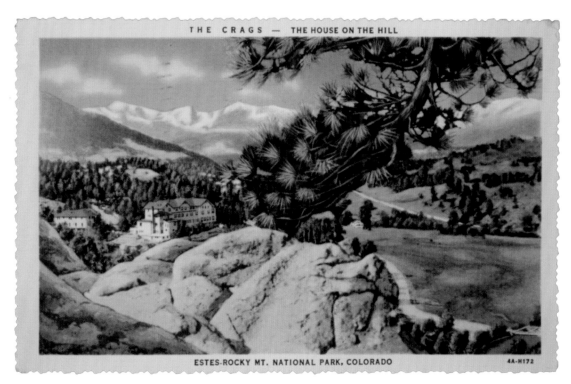

Curt Teich & Co., *Estes, Rocky Mountain National Park, Colorado*, ca. 1940

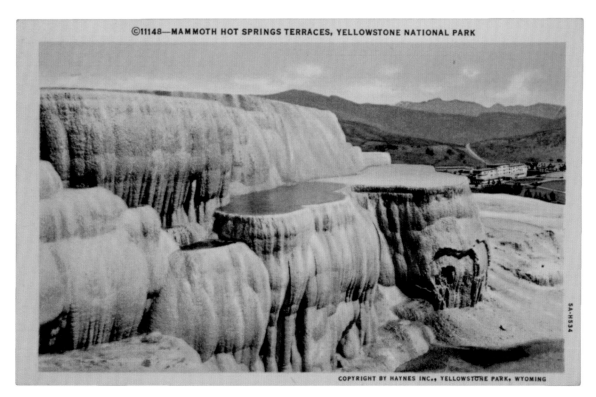

Frank Jay Haynes, *Mammoth Hot Springs Terraces, Yellowstone National Park*, ca. 1950

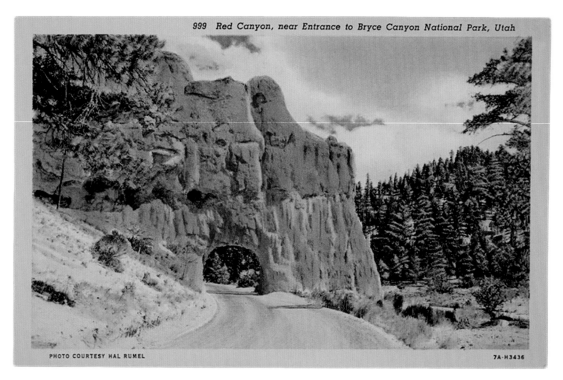

Hal Rumel, *Red Canyon, near Entrance to Bryce Canyon National Park, Utah*, ca. 1940

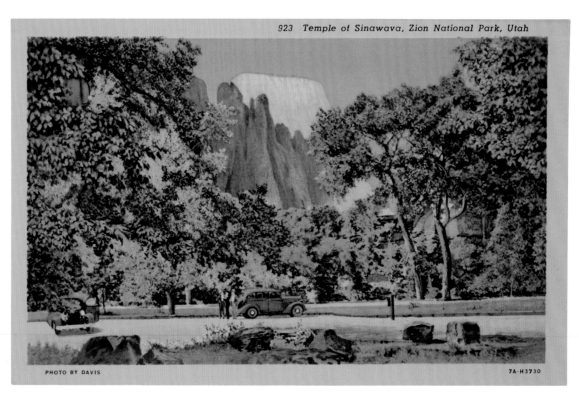

Deseret News, *Temple of Sinawava, Zion National Park, Utah*, ca. 1940

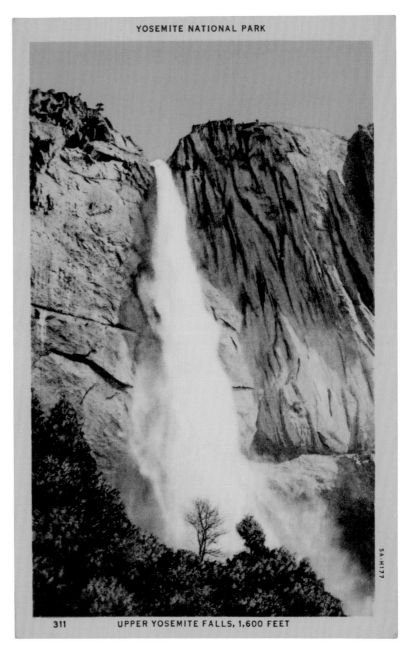

Western Publishing & Novelty Company, *Yosemite National Park,*
Upper Yosemite Falls, 1,600 Feet, ca. 1940

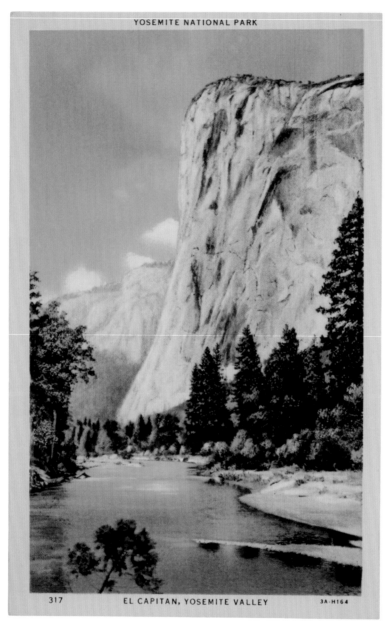

YOSEMITE NATIONAL PARK

317 EL CAPITAN, YOSEMITE VALLEY 3A-H164

Western Publishing & Novelty Company, *Yosemite National Park, El Capitan, Yosemite Valley*, ca. 1940

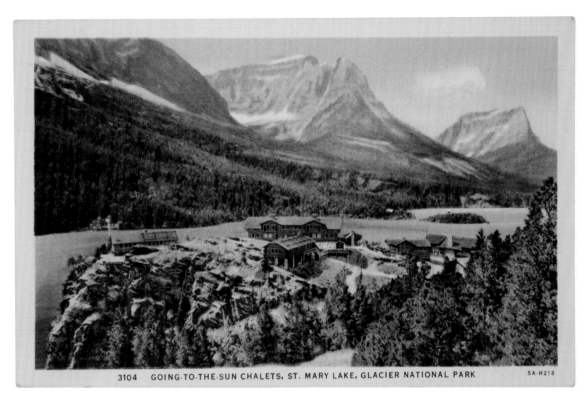

GOING·TO·THE·SUN CHALETS, ST. MARY LAKE, GLACIER NATIONAL PARK

Glacier Park Hotel Co., *Going to the Sun Chalets*,
St. Mary Lake, Glacier National Park, ca. 1935

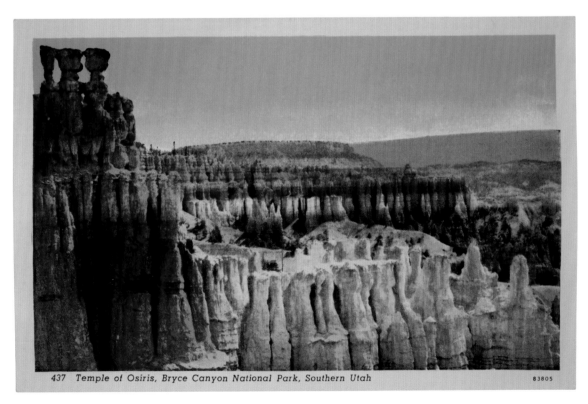

437 Temple of Osiris, Bryce Canyon National Park, Southern Utah

Deseret News, *Temple of Osiris, Bryce Canyon*
National Park, Southern Utah, ca. 1940

Ansel Adams's (American, 1902–1984) lifelong passion for the national parks began in 1916 when, at the age of fourteen, he read James Mason Hutchings's 496-page book *In the Heart of the Sierras* (1886) and convinced his parents to take him on vacation to the Yosemite Valley. Equipped with a No. 1 Brownie camera that his parents had given him, Adams took his first images of Yosemite that year. Soon after, he became involved with the Sierra Club, starting as the custodian for the club's headquarters in Yosemite and later leading tours and participating in trips to the Yosemite High Country. He was eventually elected to the board of directors and lobbied for additional areas to be set aside as national parks and monuments. By the 1930s, Adams's photographic work had become well known, and in 1941 he was invited to participate in a project to photograph all the national parks. Organized by the Secretary of the Interior, the initiative was abruptly canceled when the United States entered World War II. Adams continued the project independently, supported by a series of Guggenheim Fellowships. His images of the parks have come to represent the grandeur of the American landscape, conjuring a sense of pride for American viewers in both the land itself and the preservation of these spaces through the National Park Service. Adams's photographs have also had broad international appeal, establishing the national parks as globally recognizable icons.

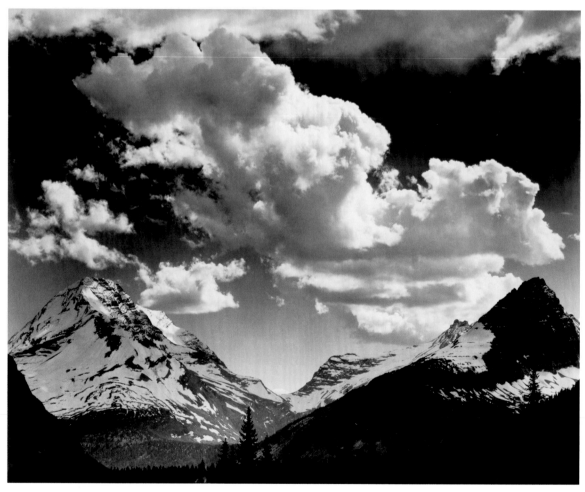

Ansel Adams, *Noon Clouds, Glacier Park, Montana*, 1942

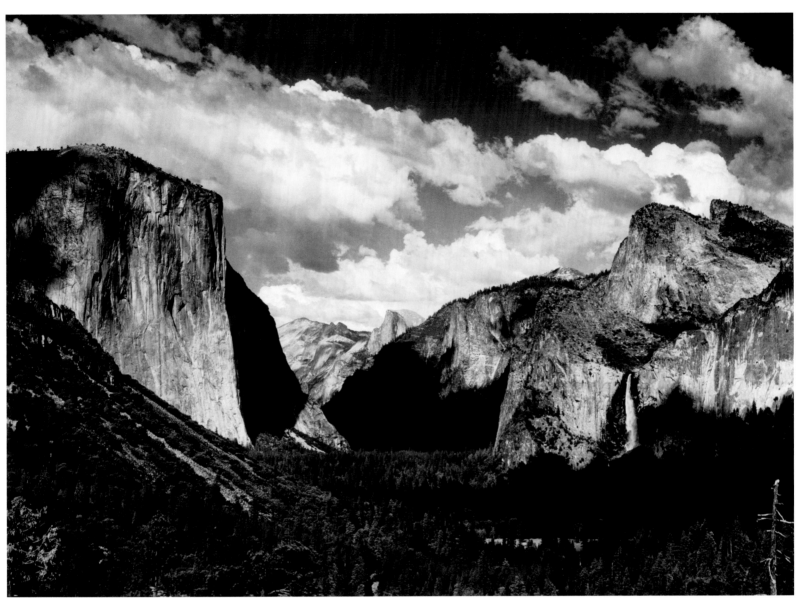

Ansel Adams, *Yosemite Valley, Summer, Yosemite National Park, California*, ca. 1935

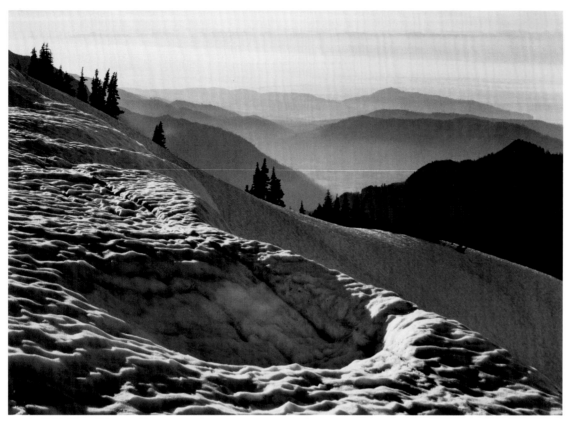

Ansel Adams, *From Hurricane Hill, Olympic National Park, Washington*, 1948

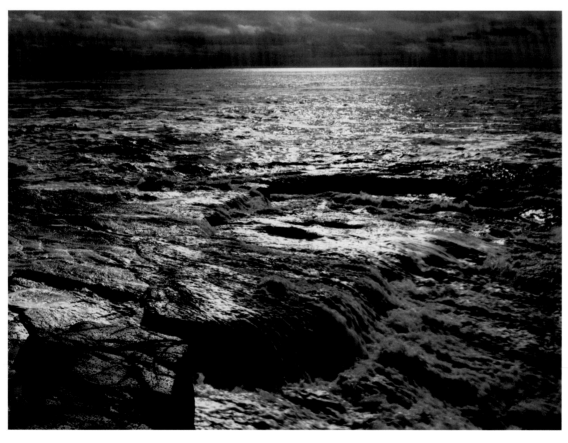

Ansel Adams, *The Atlantic, Schoodic Point, Acadia National Park, Maine*, 1949;
from Portfolio Two: The National Parks & Monuments

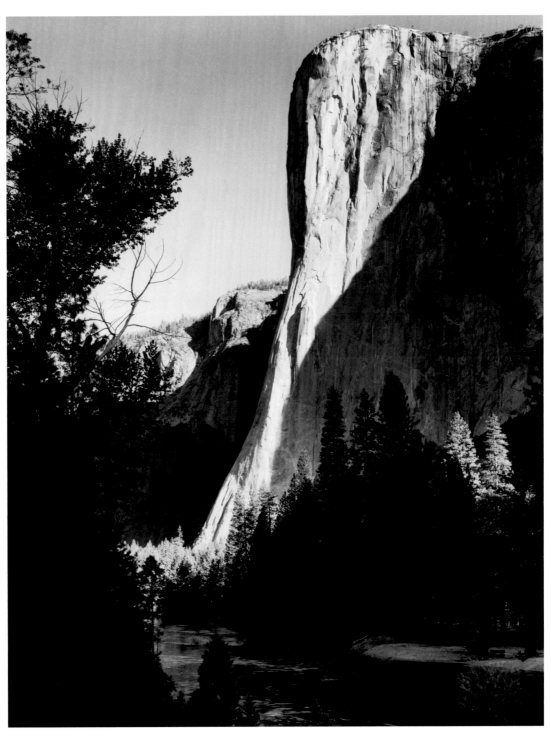

Ansel Adams, *El Capitan, Sunrise*, 1956; from Portfolio Three: Yosemite Valley

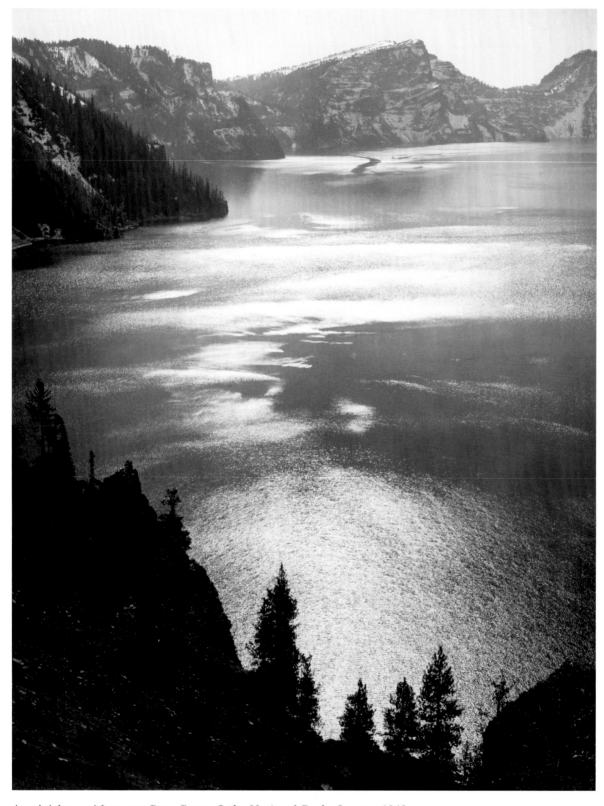

Ansel Adams, *Afternoon Sun, Crater Lake National Park, Oregon*, 1943;
from Portfolio Two: The National Parks & Monuments

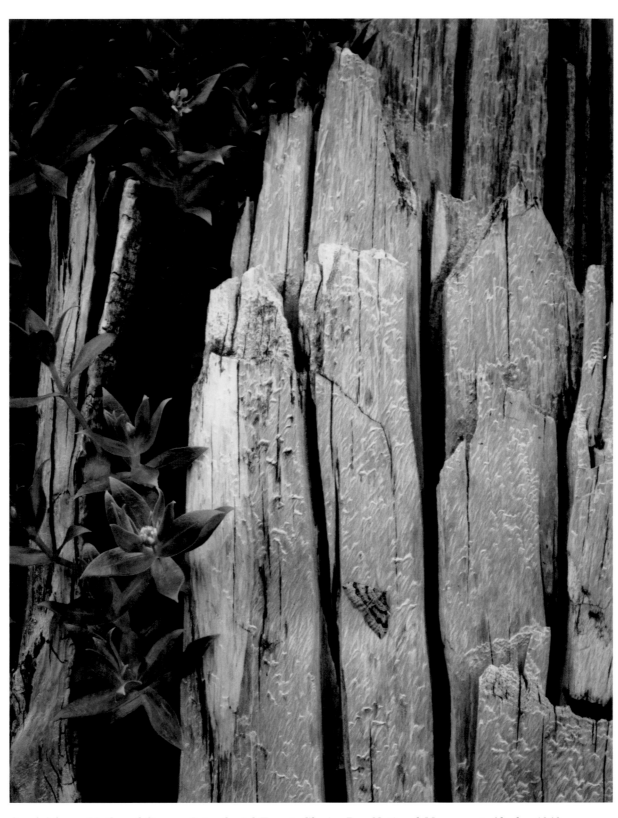

Ansel Adams, *Moth and Stump, Interglacial Forest, Glacier Bay National Monument, Alaska*, 1949;
from Portfolio Two: The National Parks & Monuments

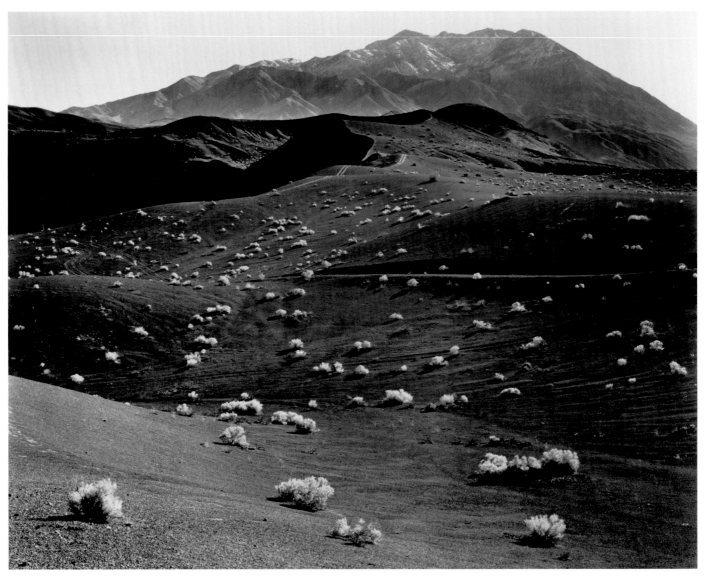

Edward Weston, *Ubehebe Crater Area, Death Valley*, 1938

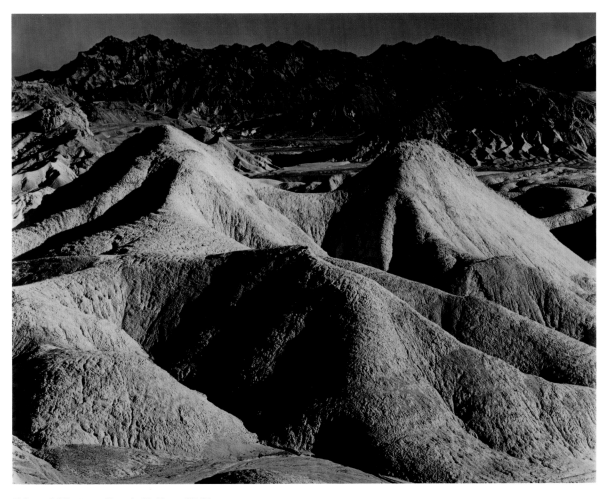

Edward Weston, *Death Valley*, 1947

Edward Weston (American, 1886–1958), a leading modernist photographer and a member of Group f/64, carefully composed images to showcase the beauty that he found in nature. Like Ansel Adams, Weston focused on composition and form; however, the two men produced incredibly different work. While Adams used images to promote the ideas of land conservation in which he so strongly believed, Weston made photographs solely as art. In 1937, Weston was awarded a Guggenheim Fellowship, the first to be granted to a photographer. With this support, he traveled throughout the western United States, concentrating a portion of his time in Death Valley, California. The next year he printed five hundred images from the over 1,260 negatives that he took during his trip.

In 1945, Weston was diagnosed with Parkinson's disease, which made it increasingly difficult for him to photograph. During his final period of work, Weston turned to color photography to explore its advantages over black-and-white mediums, making color transparencies in Death Valley with the aid of his son Cole and his assistant, Dody Warren (later Dody Weston Thompson). For Weston, color provided a greater separation of forms that could not be achieved in black-and-white. While one might have expected his color images to be more accessible to viewers, they in fact had the opposite effect; since the locations had become well known in black and white, audiences found Weston's color rather otherworldly and shocking.

Son of the German-American painter Lyonel Feininger, **Andreas Feininger** (American, b. France, 1906–1999) built a career as a freelance photographer after immigrating to the United States in 1939. This dramatic image of Grotto Geyser in Yellowstone National Park is one of a handful that he took at national parks. In this case, Feininger was most likely making images for *LIFE* magazine's series The World We Live In (1952–54), which discussed scientific topics related to Earth and the universe. His photographs appear in multiple articles related to the series, most notably the April 13, 1953, issue "The Face of the Land," which focused on geological features. For this assignment, Feininger sought out formations with unique shapes, many of which he found in national parks, due to the fact that these lands had been set aside for the express purpose of preserving such forms.

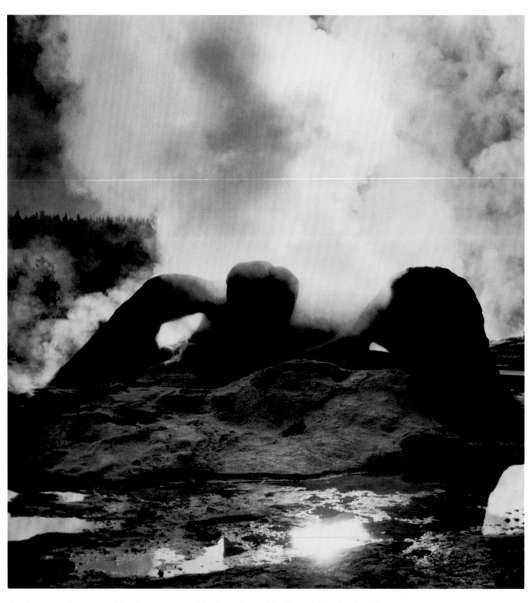

Andreas Feininger, *Grotto Geyser, Yellowstone National Park*, 1953

1961

1961

Eastman Kodak
Company introduces
the Carousel projector.

1962

Petrified Forest
National Park
is established.

1963

Polaroid introduces Polacolor, the first
instant color film.

Eliot Porter and David Brower publish
their book, *The Place No One Knew:
Glen Canyon on the Colorado*. The book
records the area just before construction
of the Glen Canyon Dam is completed
in 1966, causing water to flood the valley
in order to create the reservoir known
as Lake Powell.

1964

The Wilderness Act is signed into law,
allowing for certain lands to be set aside
with the understanding that no roads
or permanent structures will be built
in those areas.

1965

The Super 8 film format
is introduced to the home
movie market.

1968

The Wild and Scenic Rivers Act establishes
eight rivers and their adjacent lands as
areas that "possess outstanding scenic,
recreational, geologic, fish and wildlife,
historic, or cultural values."

North Cascades and Redwood
are established as national parks.

1971

Arches and Capitol
Reef are established
as national parks.

1972

National park attendance reaches
165 million visitors per year.

Guadalupe Mountains National
Park is established.

1973

The scientific role of the parks is reinforced
with the Endangered Species Act, which
requires federal agencies to "seek to conserve
endangered species and threatened species."

1975

Voyageurs National
Park is established.

1977–79

The Rephotographic Survey Project, a group
of photographers and historians, seeks out
and photographs over 120 views first imaged
in the nineteenth century.

1978

President Jimmy Carter signs the National
Parks and Recreation Act, reconfirming the
nation's commitment to preserving national
heritage and providing areas of recreation
for all people.

Konica introduces the first point-and-shoot,
autofocus camera.

Badlands and Theodore Roosevelt
are established as national parks.

1980

The Alaska National Interest Lands
Conservation Act doubles the land managed
by the National Park Service by converting
more than 45 million acres of land in Alaska
into national parks and preserves.

Channel Islands, Biscayne, Gates of the Arctic,
Glacier Bay, Katmai, Kenai Fjords, Kobuk
Valley, Lake Clark, and Wrangell-St. Elias
are established as national parks

1980

Minor White, *Moencopi Strata, Capitol Reef, Utah*, 1962

For **Minor White** (American, 1908–1976), photographs were a form of self-expression steeped in metaphor and meaning. In 1946, Ansel Adams invited White to teach creative photography at the California School of Fine Arts in San Francisco (now the San Francisco Art Institute). While White knew and was influenced by many of the Group f/64 photographers, images such as *Grand Teton National Park, Wyoming*, move beyond the desire to make a pure photographic record of a subject. Rather than glorifying the landscape itself, White emphasized his experience of light within nature. The mountains are shrouded in the sun's rays, and the foreground is foreboding, save for the glowing river. Each element of the photograph adds texture and hidden details. For White, this moment is defined by the power of Zen, pure emotion and life experience, all retold through the photograph. It is no accident that many of his images were made in national parks and other natural spaces, as these areas are considered places that capture the purity and power of the land without the disruption of human elements.

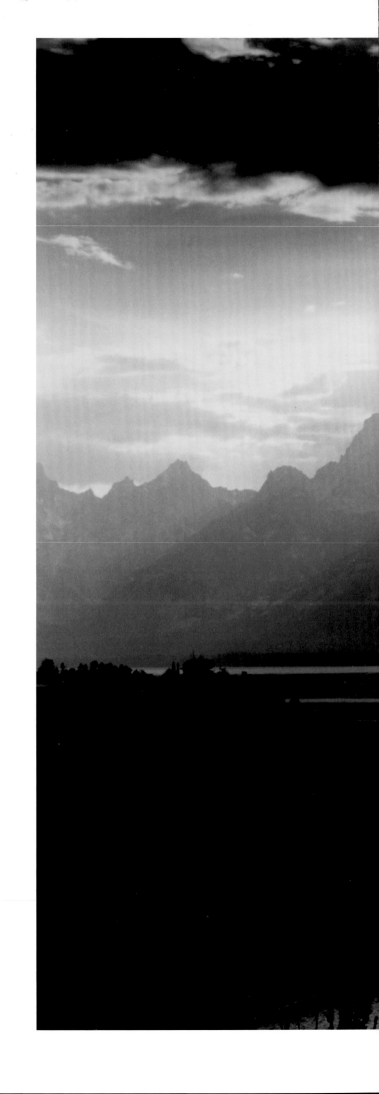

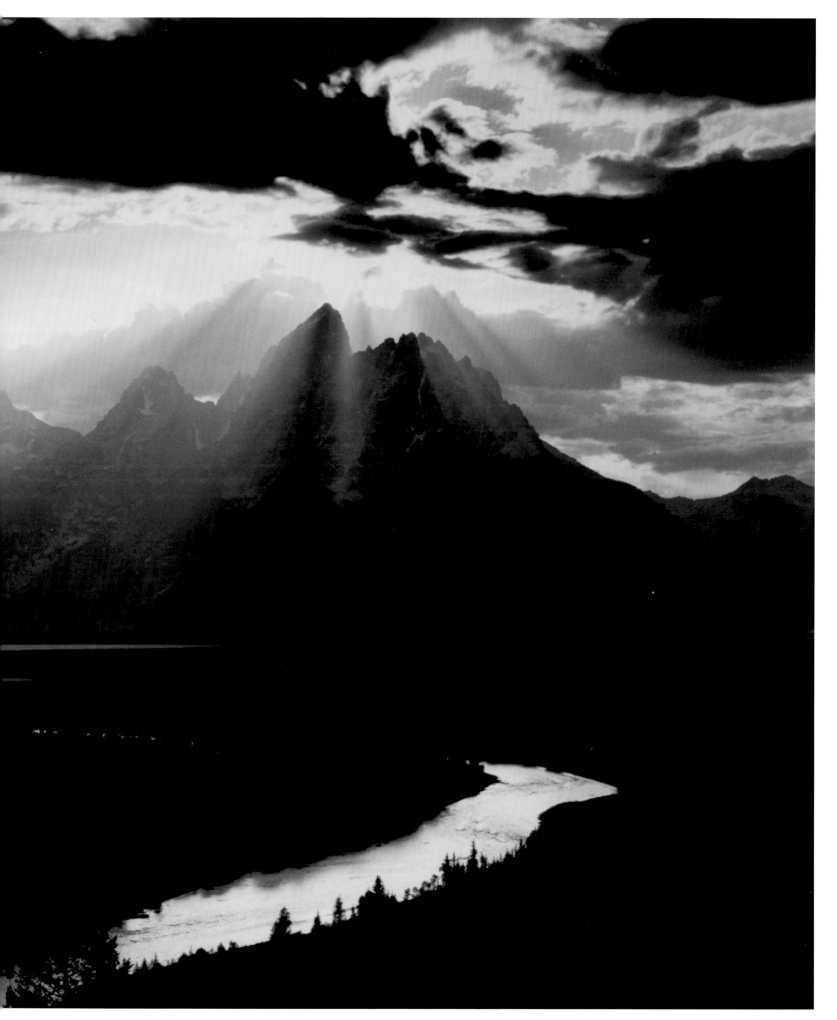

Minor White, *Grand Teton National Park, Wyoming*, 1959

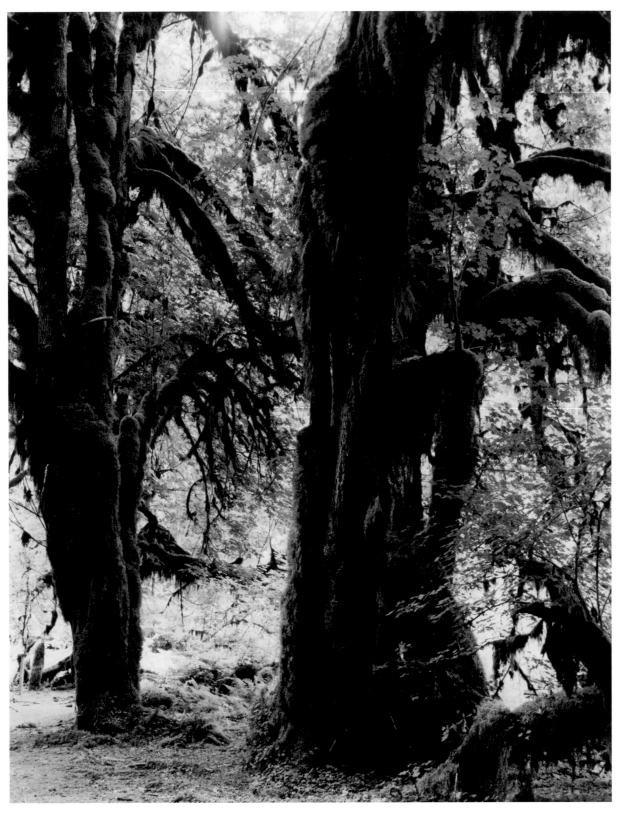

Philip Hyde, *Hall of Mosses—Hoh River Rain Forest, Olympic National Park, Washington*, 1955

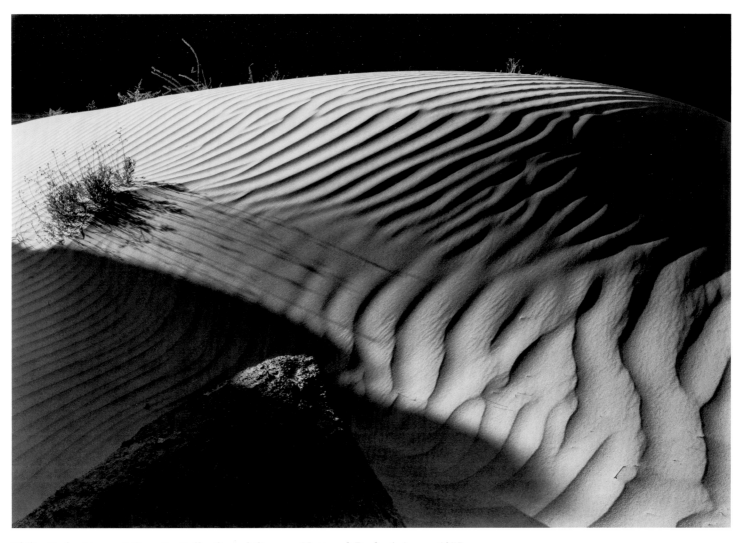

Philip Hyde, *Dune at Granite Falls, Grand Canyon National Park, Arizona*, 1955

In 1946, **Philip Hyde** (American, 1921–2006) became one of the first students to attend the newly formed photography program at the California School of Fine Arts (now the San Francisco Art Institute). Here he studied under Edward Weston, Minor White, Imogen Cunningham, Dorothea Lange, and many other influential photographers of the time. After graduating, Hyde served as the official photographer of the Sierra Club High Trip during the summer of 1950, thus beginning his long relationship with the organization. His involvement with the club blossomed into relationships with other groups, including the Wilderness Society and the National Audubon Society. Hyde's photographic work was used to advocate for and realize the preservation of places such as the Grand Canyon. While he photographed the characteristic vantages of many national parks, his images also show atypical views, such as a sand dune at the Grand Canyon.

Explorer **Bradford Washburn** (American, 1910–2007) began climbing mountains at the age of eleven, and by sixteen he had scaled the Matterhorn in Switzerland as well as Mount Blanc in the French Alps. In 1948, he climbed Denali (then known as Mount McKinley) in Alaska with his wife, Barbara, and a crew of men, several of whom were filming a documentary for RKO Radio Pictures. During the ninety-day climb, the Washburns summited the 20,322-foot peak; although it was Bradford's fourth trek up the mountain, Barbara became the first woman to accomplish this feat. Bradford was also an avid photographer, often taking images from an airplane as a way to map the areas before his climbs. His photographs are striking renderings of these remote locations that not only provide information, but also show the sweeping beauty of peaks surrounded by clouds or the humbling scale of mountains in comparison to the climbers that periodically appear in his images.

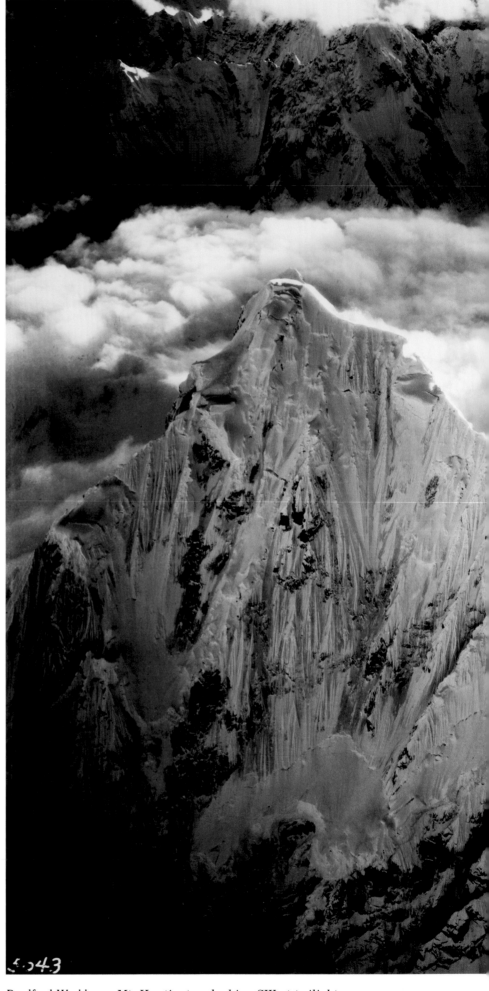

Bradford Washburn, *Mt. Huntington, looking SW at twilight, alt. 14,000 ft. Alaska*, October 3, 1964

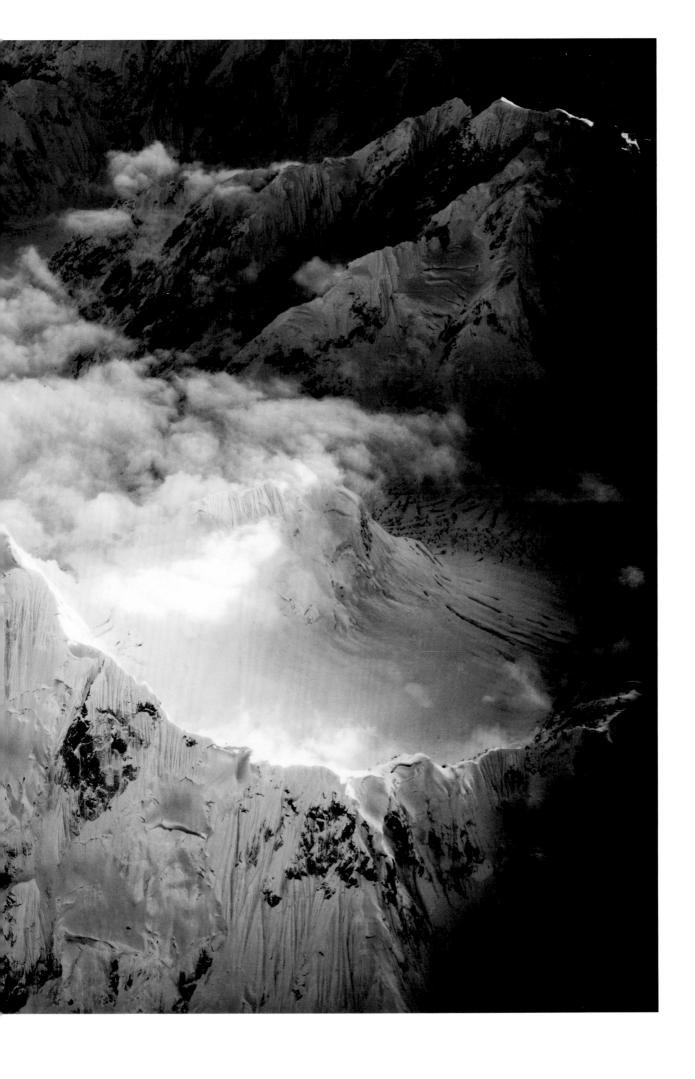

Eliot Porter (American, 1901–1990) brought his love of nature and an acute understanding of science to his work as a photographer. As one of the first noncommercial artists to photograph and print in color, Porter was influenced by but diverged from the legacy of other landscape photographers such as Ansel Adams. Avoiding monumental depictions of grand vistas, Porter instead presented nature on an accessible scale that emphasizes details like a single tree, a bird emerging from its nest, or a waterfall flowing over the face of a rock wall (as seen here), thereby mimicking the elements that one could observe if standing in the landscape. In 1962, Porter partnered with David Brower, the executive director of the Sierra Club, to create the book *In Wildness Is the Preservation of the World*. The collaboration led to another publication the following year, *The Place No One Knew*, which records the Glen Canyon area before it was drastically changed by the addition of a dam. With this project, Porter came to realize that his photographs could be used to inform the public about conservation issues, ultimately impacting the preservation of these sites. His efforts allowed him to continue photographing the natural environments he loved throughout the United States, including Great Smoky Mountains National Park.

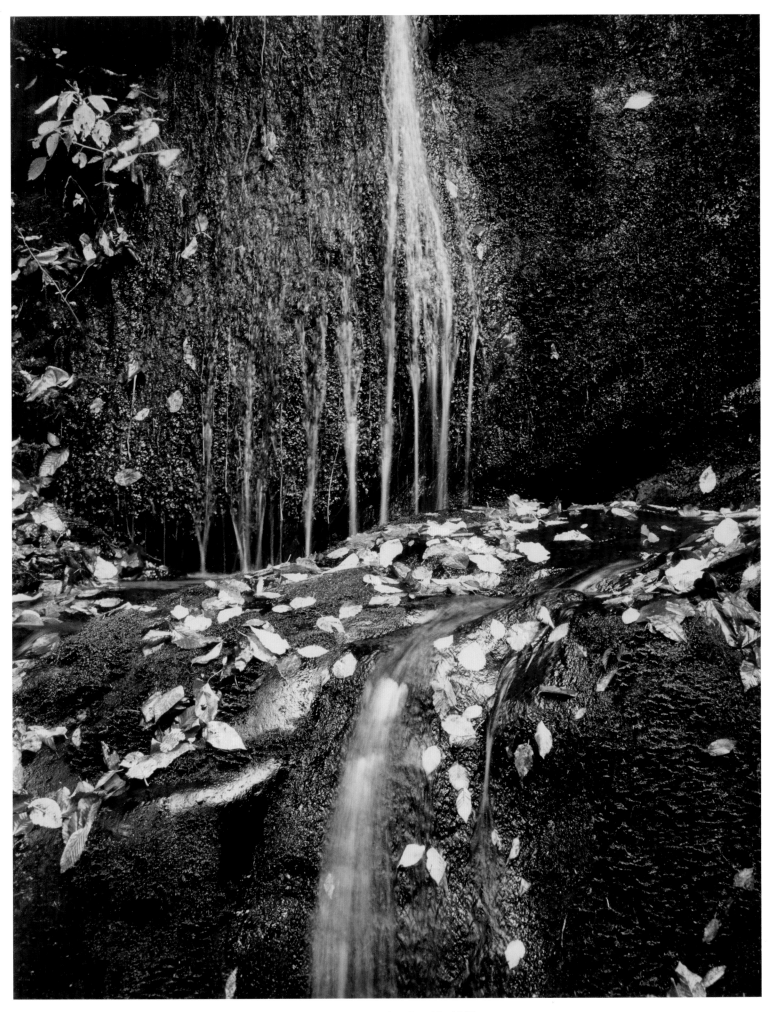

Eliot Porter, *Running Water, Roaring Fork Road, Gt. Smoky Mts*, October 10, 1967

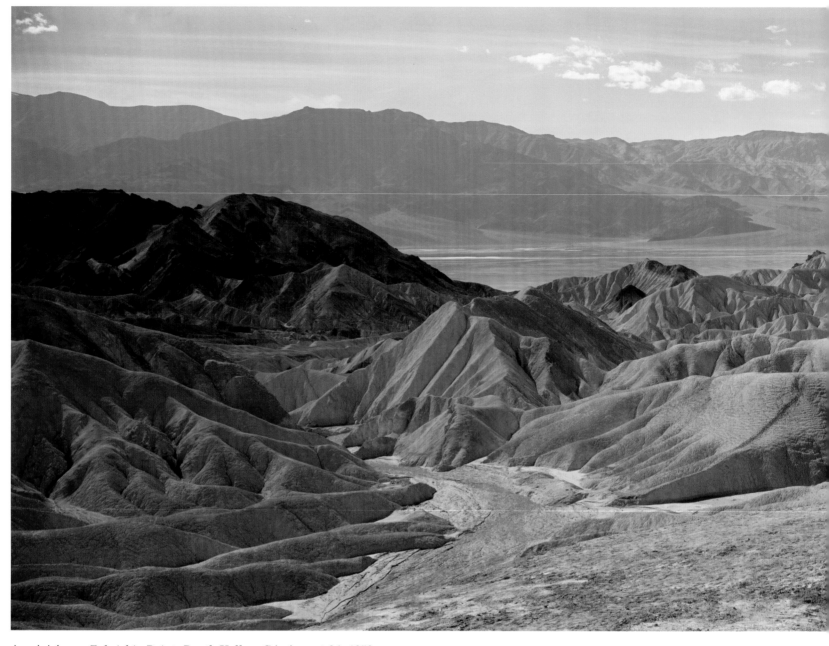

Ansel Adams, *Zabriskie Point, Death Valley, CA*, August 24, 1959

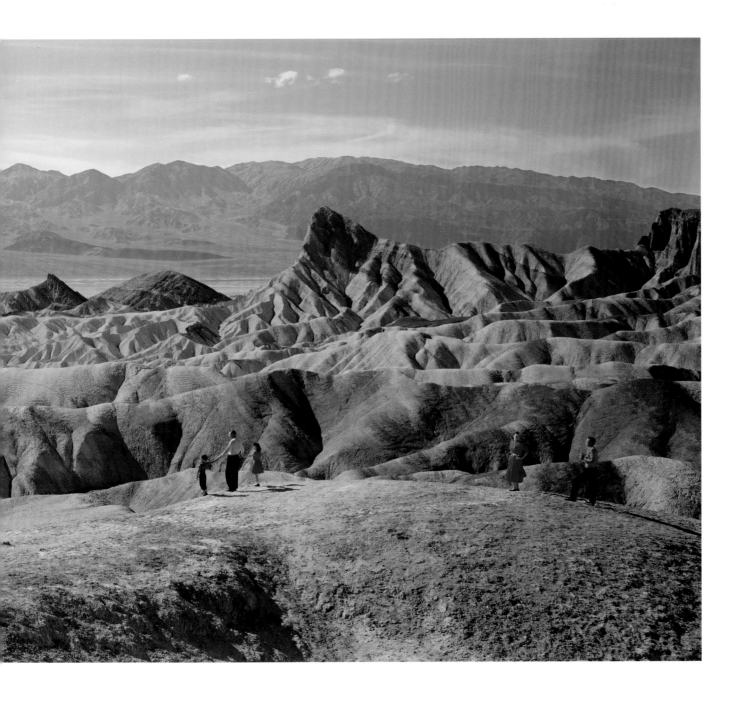

Between 1950 and 1990, Kodak produced a series of advertisements that came to be known as Coloramas. The photographs were displayed as 18-by-60-foot backlit transparencies at Grand Central Station in New York City. A new Colorama was hung every month or two, typically displaying seasonal themes or far-off places such as Europe, Africa, or even the moon. The images often show people using Kodak products or offer suggestions for what occasions might be worth documenting, such as a family vacation. By the mid-twentieth century, photography was on par with visiting the national parks as a popular leisure activity. Kodak hired a variety of photographers, including Eliot Porter and Ansel Adams, to make Coloramas over the years. This 1959 image of Death Valley National Park, taken by Adams, depicts a family enjoying the view at Zabriskie Point. Adams emphasized the ease of access that everyday visitors had to the park as well as their ability to capture the experience in their own snapshots. This particular image is in stark contrast to Adams's own black-and-white photography, which typically portrays the landscape with a grandeur untouched by man's presence. The advertisement also demonstrates how far both national parks and photography had evolved over the past seventy-five years, when previously only the wealthiest families could visit the parks and photographs were made by intrepid explorers who carried multiple cameras and glass plates.

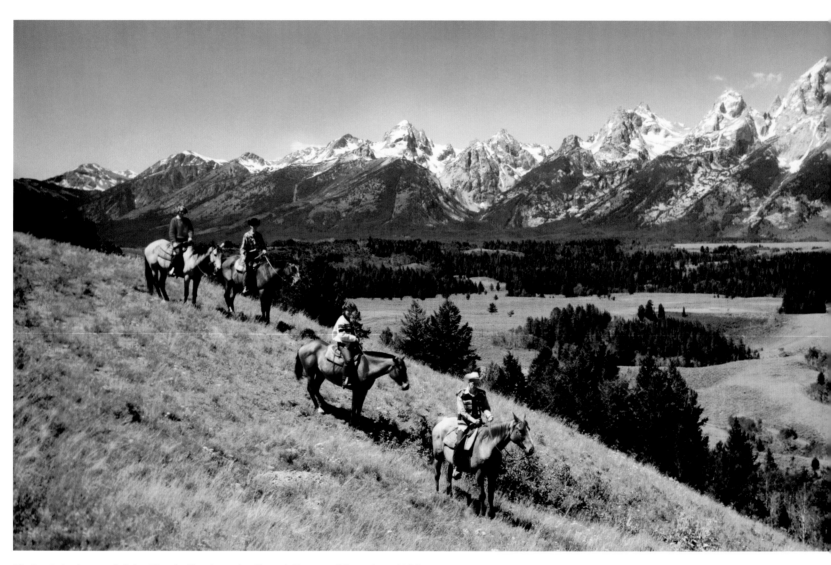

Herbert Archer and John Hood, *Cowboys in Grand Tetons, Wyoming*, 1964

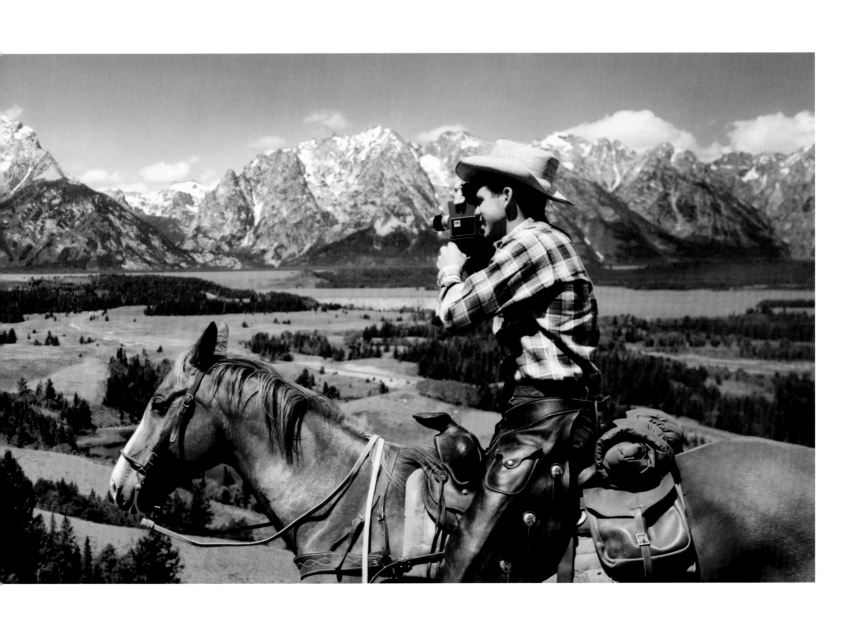

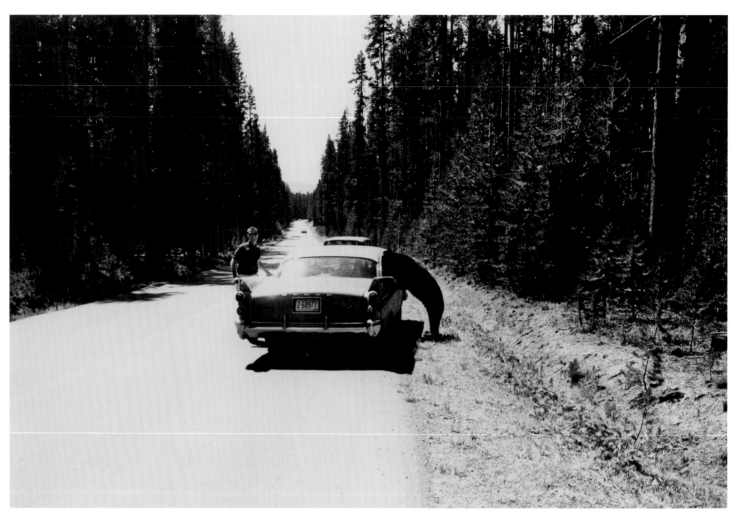

Garry Winogrand, *Yellowstone National Park*, 1964

One of the best-known street photographers of the 1960s and 1970s, **Garry Winogrand** (American, 1928–1984) turned his camera on subjects that many had previously overlooked. In a culture where we are taught not to stare, Winogrand's images allow us to peer freely into the lives of others. One photograph taken in Yellowstone National Park captures a man casually standing next to his car, while a bear seems to lean in for a conversation with other passengers. Another image depicts a collection of park stickers proudly displayed on the window of a car—loaded up with spare tires and moose antlers—while a geyser steams in the background. With a striking sense of humor, these photographs show the tourist's perspective in a manner that differs markedly from the Colorama advertisement. Instead of foregrounding the historic landscape, we see tourism in the national parks as it really is—an automobile adventure during which we collect family stories, treasures, and photographs—driven by our desire to seek out these now-iconic lands.

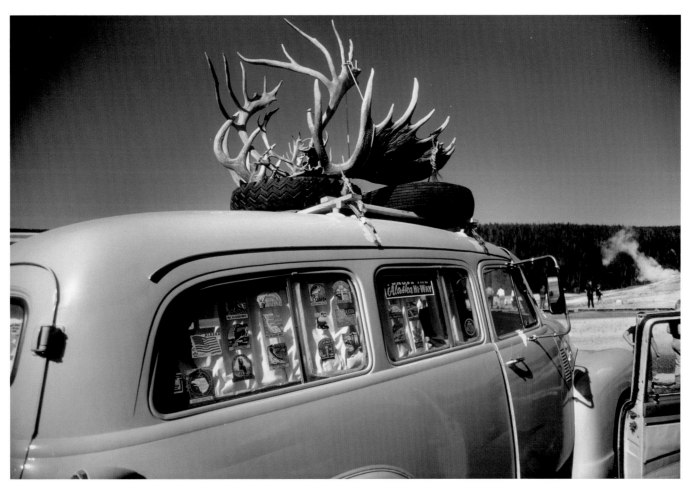

Garry Winogrand, *Yellowstone National Park*, 1964

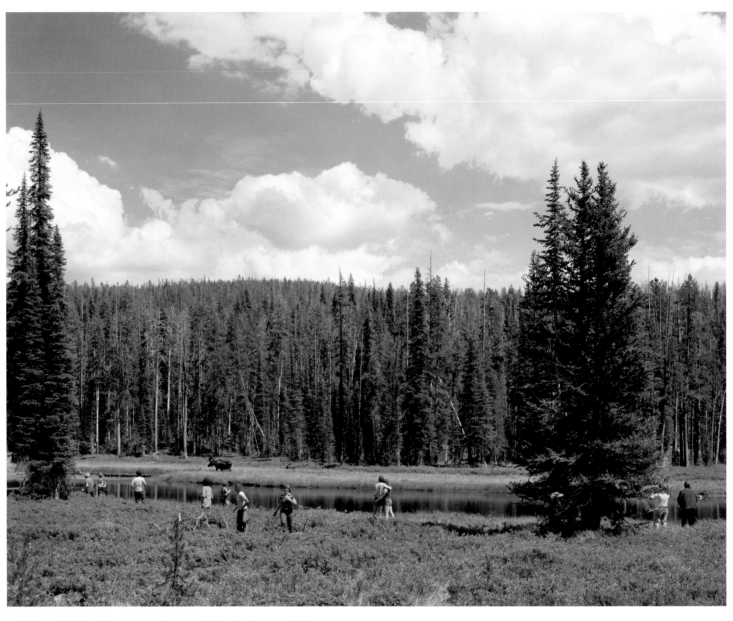

Joel Sternfeld, *Yellowstone National Park*, August 1979

Joel Sternfeld (American, b. 1944) traveled across the United States capturing images of the American experience. Like the Farm Security Administration photographers of the 1930s, or Robert Frank and his epic cross-country journey during the 1950s, Sternfeld explored America's collective identity by recording the ordinary lives of everyday people. His image of Yellowstone National Park captures a group of visitors gawking at a moose. While the animal appears serenely settled in the landscape, the visitors feel out of place, having crossed a field to gain a better view. As one couple stands embracing each other in awe of the moment, another pair abandons the scene. With its gentle humor, Sternfeld's photograph touches on the idea that experiencing the wilderness of a national park is no longer a private endeavor. These pristine spaces, shown as unfettered natural lands in advertisements and historic photographs, have become synonymous with tourism.

1981

1983
Nikon introduces the F3AF, the first autofocus 35mm SLR.

1986
Great Basin National Park is established.

1988
Len Jenshel receives a grant from the Graham Foundation, which allows him to travel and photograph in the American West.

National Park of American Samoa is established.

1992
Hundreds of parks professionals and other experts meet to commemorate the seventy-fifth anniversary of the National Parks Service. They create the Vail Agenda, which summarizes the status of parks management and makes recommendations for the future.

Dry Tortugas National Park is established.

1990
The Native American Graves Protection and Repatriation Act strengthens protection of Native American burial sites and directs museums to repatriate any remains held back to descendants for reburial.

Adobe Photoshop 1.0 is released.

1995
First consumer digital cameras appear: the Kodak DC40 camera (March 28, 1995) and the Casio QV-11 (with LCD monitor in late 1995).

1994
Martin Parr becomes a member of Magnum Photos.

Saguaro, Death Valley, and Joshua Tree are established as national parks.

1997–2000
As a continuation of the Rephotographic Survey Project of 1977 to 1979, a team of photographers revisits more than 110 sites, creating the Third View project.

1997
Kodak DC210— the first amateur 1 megapixel camera is released.

1998
Sergey Brin and Larry Page found Google.

1999
Nikon releases the D1, which is the first professional digital SLR by a major manufacturer.

Black Canyon of the Gunnison National Park is established.

2000
It is estimated that 86 billion photographs are made during the year 2000.

Cuyahoga Valley National Park is established.

2003
Congaree National Park is established.

2004
Eastman Kodak Company ceases production of film cameras.

Flickr and Facebook are launched.

Marion Belanger is artist-in-residence at Everglades National Park in Florida.

Great Sand Dunes National Park is established.

2007
The first iPhone is introduced.

2010
The Instagram application for the iPhone is released and by the end of the year has one million users. By 2012 Instagram has over 14 million users and hosts almost one billion photographs.

The Impossible Project starts production of instant film for Polaroid cameras, since Polaroid declared bankruptcy in 2001.

Abelardo Morell begins to use his tent camera to photograph within the National Parks.

Lee Friedlander's series America by Car is published in a book of the same title.

2009
Ken Burns's six-part documentary, *The National Parks: America's Best Idea*, first airs on Public Television.

Stephen Shore's book *Merced River* is published.

Kodak ceases production of Kodachrome film.

2008
National Geographic releases its first all-digital issue of the magazine.

2010

In his 2009 book *Merced River*, **Stephen Shore** (American, b. 1947) presents a series of images taken at Yosemite National Park. The subjects range from a typical landscape, complete with tall pines and mountain peaks, to a boy swimming in the river or an abandoned baby stroller on the shore. The viewer ultimately discovers that the photographs are part of a larger scene, with each image directly cropped from this single picture taken in August 1979. While the book serves as a meditation on both the place and people depicted, it is also a poignant reminder of the different ways photography can be used. Conceptually, the image takes a classic landscape, reminiscent of one Carleton Watkins produced in 1863, and dissects it into segments that together represent the expansive history of photography in the parks. While some vignettes read like modernist landscapes or the street photographs of Garry Winogrand, others could be the postcards and snapshots of generations of visitors to that locale. The history of America's national parks is equally unescapable for photographers and tourists. While both attempt to make something new—be it a printed image or a family memory—both must also contend with expectations created by their predecessors. At this point in time, we cannot experience the iconic landscapes of the national parks without feeling like we are in a photograph.

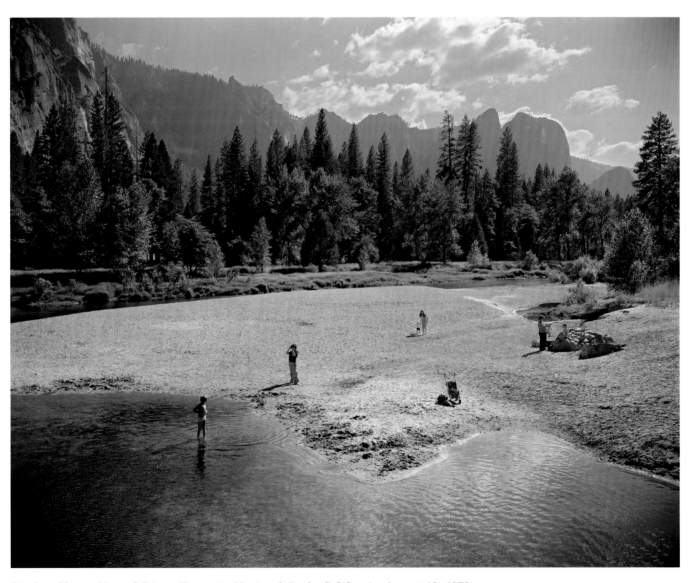

Stephen Shore, *Merced River, Yosemite National Park, California*, August 13, 1979

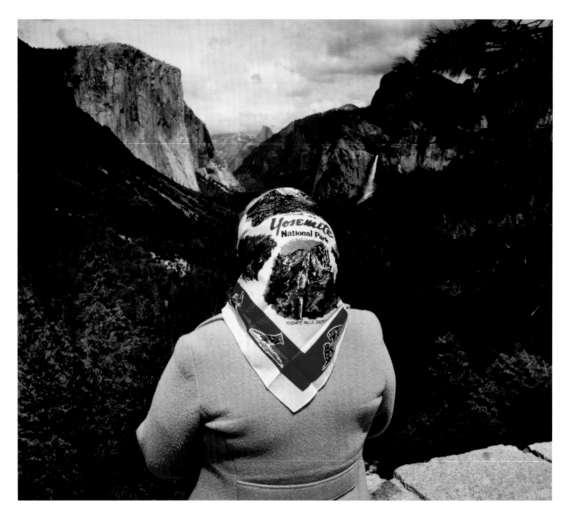

Roger Minick, *Woman with Scarf at Inspiration Point, Yosemite National Park*, 1980; from the series Sightseers

While teaching an Ansel Adams workshop at Yosemite National Park in 1976, **Roger Minick** (American, b. 1944) was inspired to begin a series on sightseers. He was particularly interested in how people experienced the parks, the infrastructure that guided their visits, and the sense of awe that struck them at each vista, as if they were on a religious pilgrimage. Minick originally began the project with black-and-white film, but quickly changed to color in order to emphasize the vivid fabrics worn by visitors in contrast with the natural landscape. Additionally, he often used a flash to fill in the light on his subjects, recognizing that this often added an artificial quality to the scenery. While many of his images read much like family snapshots—people standing before a scenic view partially obscured and flattened in the background—the series also includes atypical scenes, such as bus parking at Yosemite's Inspiration Point or a boardwalk with guard rails that both protect visitors from the scalding waters at Yellowstone and limit their ability to damage Minerva Terrace. While Minick's work serves as a time capsule of 1980s American culture, it also pokes fun at our obsession with these spaces and the ways in which the parks are both contained and consumed.

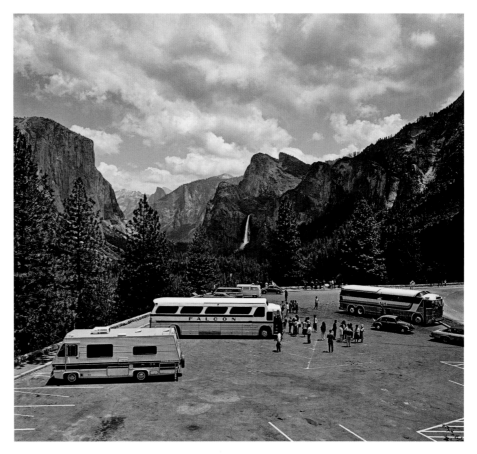

Roger Minick, *Buses & Motorhomes at Inspiration Point, Yosemite National Park, California*, 1980; from the series Sightseers

Roger Minick, *Couple Viewing Grand Tetons, Grand Teton National Park, Wyoming*, 1980; from the series Sightseers

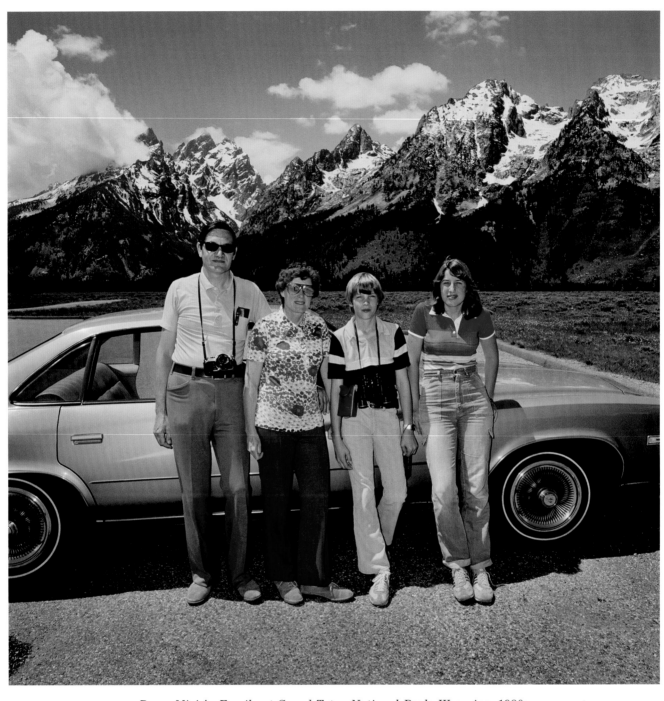

Roger Minick, *Family at Grand Teton National Park, Wyoming*, 1980;
from the series Sightseers

Roger Minick, *Photographing Old Faithful Geyser, Yellowstone National Park, Wyoming*, 1980;
from the series Sightseers

Tseng Kwong Chi's (American, b. Hong Kong, 1950–1990) family moved from Hong Kong to Canada when he was sixteen years old. He eventually became a U.S. citizen, choosing to live in New York City, where he felt free to express his individualism, with a circle of friends including Andy Warhol, Keith Haring, and Cindy Sherman. In 1979, Tseng began his series East Meets West in reaction to President Nixon's recent trip to China. In these works, Tseng depicted himself at popular sites around the world, donning a Mao-inspired uniform and embodying a cool, detached demeanor. His performance is that of a tourist posing for the camera, but there is also a coldness to his facial expression that mimicks his perception of diplomatic relations. The series explores self-expression, identity, and the perpetuation of Western stereotypes while also drawing upon the notion of tourists who compulsively seek to collect photographs of themselves at cultural sites. In this image at the Grand Canyon, Tseng faces the landscape rather than the camera, which is unusual in this body of work. His assumed pose here draws attention to the grand vista seen from the canyon's rim, recreating the sense of wonder and the moment of pause that visitors often experience at this destination.

Tseng Kwong Chi, *Grand Canyon, Arizona*, 1987

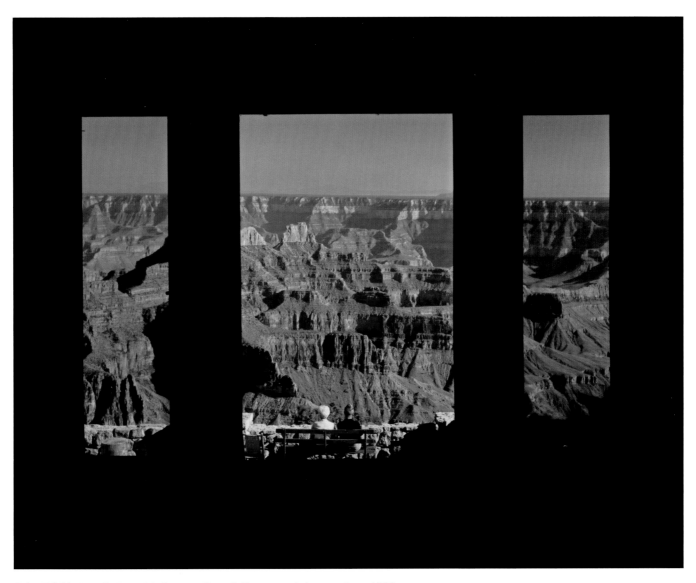

John Pfahl, *North Rim Highway, Grand Canyon, Arizona*, June 1980;
from the series Picture Windows

While most people experience the national parks during day trips or vacation excursions, a select few own homes or businesses that overlook the preserved landscapes. In his series *Picture Windows*, **John Pfahl** (American, b. 1939) sought out these destinations, framing his photographs behind the glass. For Pfahl, the rooms were ever-present cameras, forever holding the view and awaiting film to record it. Some images include the artifacts of the individuals who inhabit the space: a desk sits quietly in the darkness or a cross and flowers become part of the scene. Pfahl commented that the homeowners were strangers he approached, though many "expressed their desire to share their view with others, as if it were a nondepletable treasure." Pfahl thus stepped in as a visitor who not only shared their view but also photographed it so that it could be seen by others. His images depict beautiful landscapes as if they are already framed pictures on a wall, highlighting the fact that these spaces have risen to the status of art and represent symbols of national identity. Yet they also draw attention to the man-made aspects that disrupt the views. With the same careful balance of preservation and access that the park system navigates, Pfahl's images demonstrate how we can simultaneously enjoy nature and alter it with our presence.

John Pfahl, *2 Balanced Rock Drive, Springdale, Utah*, June 1980; from the series Picture Windows

Len Jenshel, *Joshua Tree National Park, California*, 1990

While many photographers use color to steep their images in reality, **Len Jenshel** (American, b. 1949) employs vibrant hues to make his photographs appear otherworldly. In 1988, Jenshel received a grant from the Graham Foundation that resulted in his book *Travels in the American West*, and he continued to photograph the landscape afterward. In this body of work, Jenshel approached each of the spaces as if no one had ever experienced it before, a method that lends a sense of fantasy to the images.

While the resulting photographs include scenes taken in national parks, the vantages diverge from the now-cliché shots normally seen in magazines or calendars. Instead, the photographs describe the human elements found in each landscape—a roadway, tunnel, cattle guard, or hotel interior—which are rendered absurd by Jenshel's use of heavily saturated colors that stream from light sources such as room fixtures or a car's head- or taillights.

Len Jenshel, *Best Western, Mammoth Hot Springs, Gardiner, Montana*, 1990

Len Jenshel, *Tunnel, Zion National Park, Utah*, 1988

Len Jenshel, *Cattle Guard, Great Basin National Park, Nevada*, 1987

In 1994 **Martin Parr** (British, b. 1952) became a member of Magnum Photos, a cooperative of photographers who "chronicle the world and interpret its peoples, events, issues, and personalities." With a cutting sense of humor and irony, Parr has spent the past two decades documenting tourist behavior at famous sights around the world, commenting on how cultural identity exists within the massive global travel industry. Parr also uses color to direct the viewer's gaze. In this image, three people sit at the rim of the Grand Canyon with their backs to the camera, the blue and red tones of their jackets drawing upon the natural shades of the landscape. One visitor also wears a feathered headdress, either mimicking or mocking the indigenous people to the area. Parr's image is unapologetic; by meshing an iconic vista with a serious cultural issue—the treatment of native populations—he reduces both down to a wry photographic joke.

Martin Parr, *The Grand Canyon, Arizona*, 1994

In his series Places of Worship (1995–2003), the German photographer **Thomas Struth** (b. 1954) surveyed locations where individuals seek to have emotional or spiritual experiences. While most of the images depict churches or temples, this photograph of Yosemite National Park seats itself in the divine sacrament of nature. Formally, the natural elements are treated with the same sense of structure that is seen in Struth's images of metropolitan cities. Yet in the wild, the human presence is dwarfed as passengers disembark from their cars to pause in wonder before the site. The trees serve as the walls of the cathedral, framing the view toward El Capitan—the altar—which rises ghostlike and supernatural in the background. Here nature appears as sublime and overwhelming as it must have been to the first explorers and photographers who entered the valley.

Thomas Struth, *El Capitan (Yosemite National Park)*, 1999

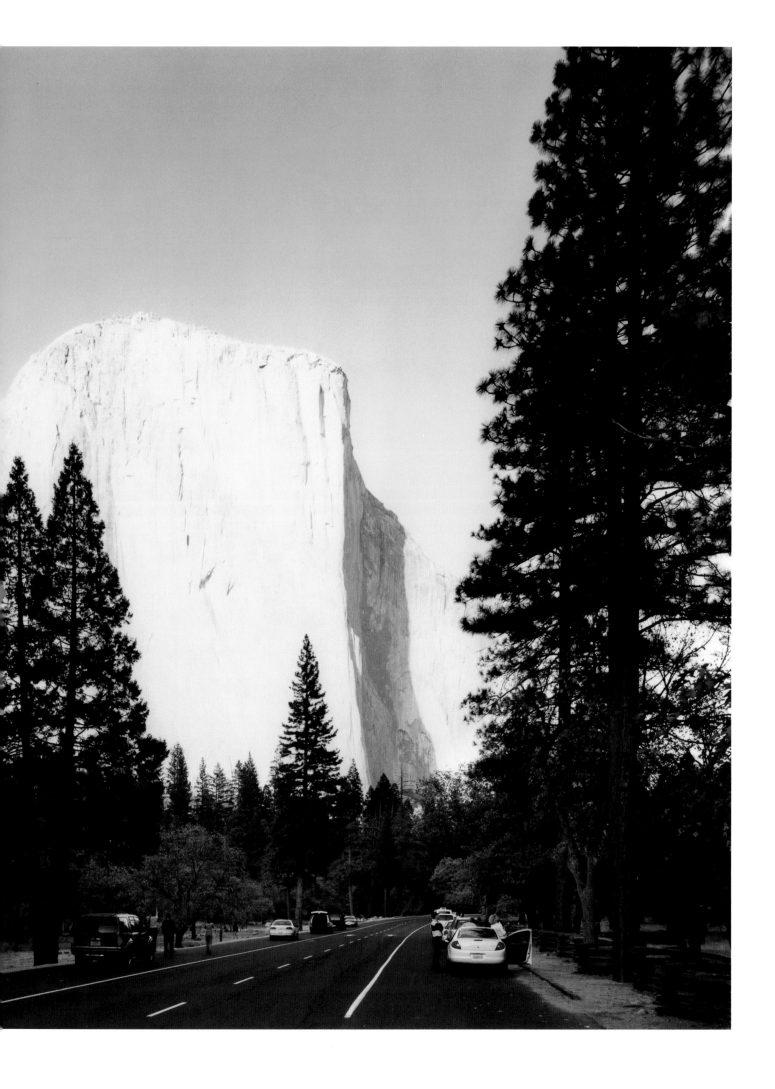

Art has played a role in promoting and preserving America's national parks since the early nineteenth century, when Albert Bierstadt and Thomas Moran painted sites in the West. Today, many of the national parks continue this tradition by offering artist-in-residence programs for writers, musicians, and visual artists. In 2004, **Marion Belanger** (American, b. 1957) was in residence at Everglades National Park in Florida. This area has a complicated history; it was considered potential farmland by early settlers and drained for development in the early 1900s. This action impacted the delicate ecosystem of plants and animals that live among the waterways, so advocates lobbied for the area to be made into a national park, which was granted in 1947. Belanger's body of work draws upon this unsettled history, documenting sites within the park, as well as those just beyond its borders. The results are often surprising, with images in the park displaying dilapidated buildings and debris, while those taken outside the park portray thriving wildlife. Ultimately, the work calls into question the ways that we divide land, making invisible borders that establish what is "important" to preserve and subdividing the fragile ecosystems that have survived for thousands of years.

Marion Belanger, *Alligator in Swamp*, 2002; from the series Everglades

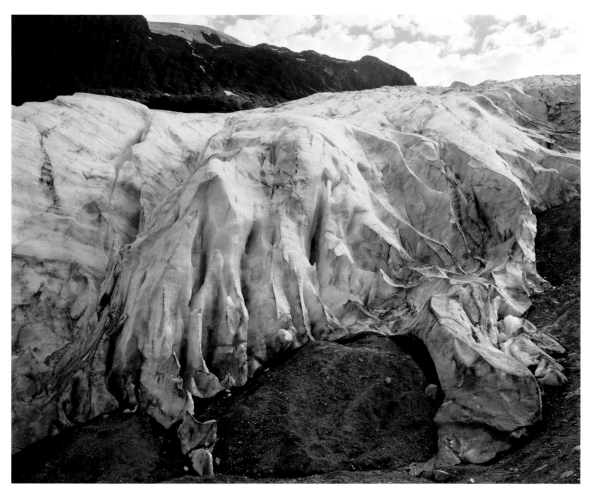

Mitch Epstein, *Exit Glacier, Kenai Fjords National Park, Alaska*, 2007

In 2003, Mitch Epstein (American, b. 1952) began his series American Power. Like photographs by Ansel Adams and Eliot Porter, Epstein's work confronts the viewer with issues of land preservation, now incorporating elements of our twenty-first-century debate. The photographs—which depict power plants, oil refineries, sweeping cities of excess, shorelines filled with debris, windmill farms, and dammed up waterways—comment on America's energy-driven lifestyle and reliance on fossil fuels. The series includes an image of Exit Glacier at Kenai Fjords National Park in Alaska, the only landmark in the park accessible by car (and even then only for half the year). Among the cooling towers and smokestacks in the series, the ice here seems to recede before our very eyes, as it pulls away from the rocks and greenery in the foreground and background. Epstein's photograph freezes the glacier in time, an effort to preserve the changing landscape—which, despite its status as a protected national park, is not immune to climate change—prompting us to pause and consider our own impact on the world.

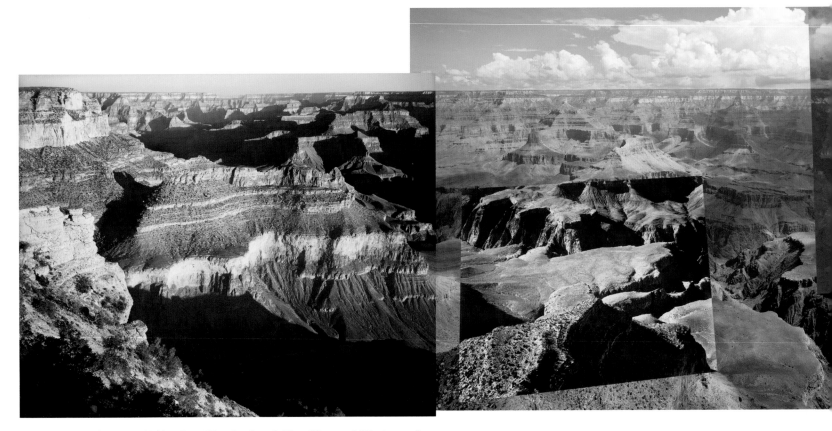

Mark Klett and Byron Wolfe, *One Hundred and Five Years of Photographs and Six Million Years of Landscapes; Panorama from Yavapai Point on the Grand Canyon Connecting Photographs by Ansel Adams, Alvin Langdon Coburn and the Detroit Publishing Company*, 2007

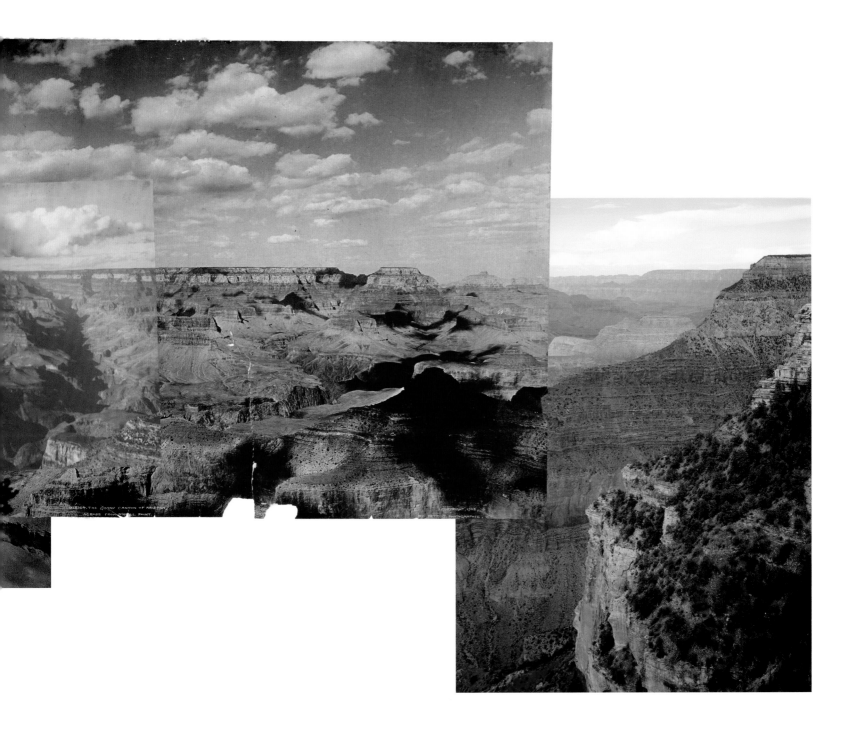

In their series Reconstructing the View, **Mark Klett** (American, b. 1952) and **Byron Wolfe** (American, b. 1967) expanded on their earlier project, Third View: A Rephotographic Survey of the American West, in which they located the sites of nineteenth-century land survey images and rephotographed them to document changes to the landscape. In the more recent series, Klett and Wolfe went beyond the basic method of rephotography, layering historic images made by varying photographers for varying purposes with their own contemporary depictions. (The historic material includes photographs by Eadweard Muybridge, Alvin Langdon Coburn, and Ansel Adams, as well as anonymous tourist postcards.) Throughout the project, subtle actions connect images taken over a century apart, as a cloud formation sweeps across the sky or a visitor balances on the ledge of a rock. The resulting constructions bring to mind the relatively short amount of time in which we have been able to record these spaces, compared to the millions of years it has taken nature to shape the landscape. Yet the images also convey that many locations appear timeless, as the land remains relatively unchanged over the years.

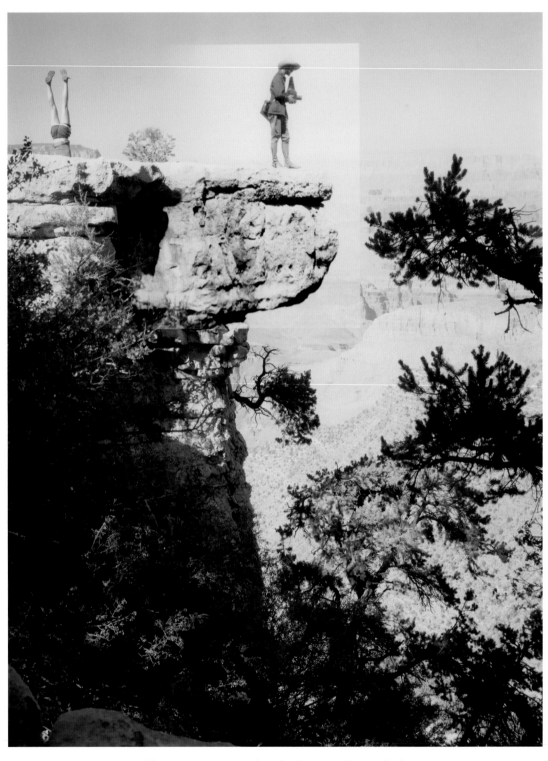

Mark Klett and Byron Wolfe, *Woman on Head and Photographer with Camera;*
Unknown Dancer and Alvin Langdon Coburn at Grand View Point, 2009

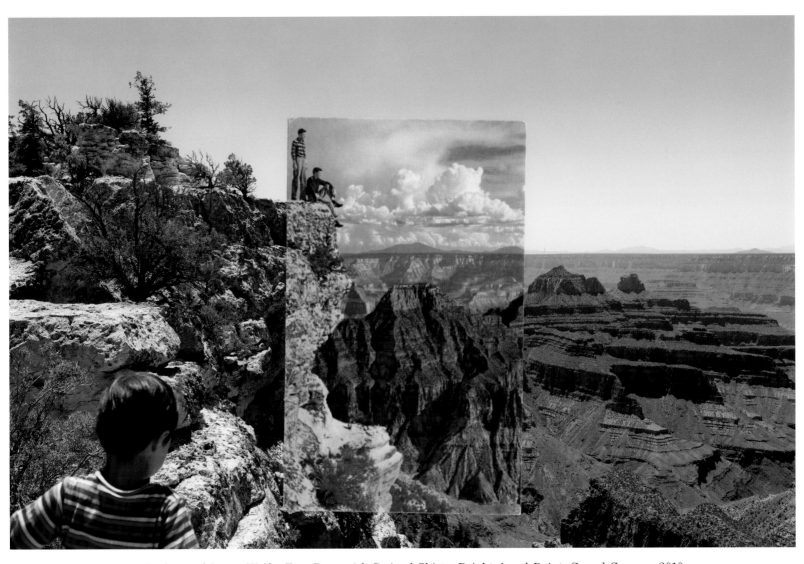

Mark Klett and Byron Wolfe, *Two Boys with Striped Shirts, Bright Angel Point, Grand Canyon*, 2010

Taiyo Onorato (Swiss, b. 1979) and Nico Krebs (Swiss, b. 1979) approach nature as a place of creation, both through natural acts and those that we impose on the landscape. The views in their images are disrupted by a commodity culture that is constantly seeking more from the environment. In *Map* (2005), a small scaffold is outfitted with a receding roadway reproduced in miniature. The "road," placed on the land in perfect perspective, disrupts the view of the seemingly untouched Death Valley National Park, calling into question the roads that have been paved to access our national parks. Similarly, *Pommes Frites* (2005) depicts an attentive audience of French fries enjoying the view at the edge of the Grand Canyon. These consumer goods are no different than the thousands of visitors who stand at the rim and perform the typical reaction of awe. With humor and play, Onorato and Krebs portray a culture where the divided highway and fast food are as iconic as the grand vista of any national park.

Taiyo Onorato and Nico Krebs, *Map*, 2005

Taiyo Onorato and Nico Krebs, *Pommes Frites*, 2005

Lee Friedlander's (American, b. 1934) series America by Car draws attention to the continued phenomenon of the American road trip. For these images, he rented cars and drove across nearly all fifty states. Photographing from inside the vehicle, Friedlander focused on subjects along the road. Here, the idea of the road trip takes on a new form, contained within the comfortable bubble of the car, which becomes more than a mode of transportation. Indeed, doorframes and mirrors become part of the landscape, establishing the foreground of each image. When Friedlander reached the national parks, the unimaginable beauty of the wilderness is supplanted by a Joshua tree made entirely of horseshoes and a friendly park ranger who impedes the mountain view. In this series, Friedlander placed himself in the position of everyman, ultimately calling into question the quality of the experience that can be had from such a sheltered vantage point.

Lee Friedlander, *Denali National Park, Alaska*, 2007

Lee Friedlander, *California*, 2008

Rebecca Norris Webb, *Badlands*, 2010

In her series My Dakota, **Rebecca Norris Webb** (American, b. 1956) explored her home state of South Dakota, including Badlands National Park and the surrounding area. Attempting to capture what the open space of the West felt like to someone who grew up there, Norris Webb was dealt an unexpected blow when her brother passed away. As she wandered, her photographic journey paralleled her emotional one. The vast spaces seem endless and lonely, an expansiveness matched only by her grief. In one image, the landscape is desolate and abandoned. Taken from the seat of her car, the photograph includes the sharp curve of the vehicle's window, adding a human element to the scene and perhaps keeping Norris Webb grounded and safe. Like a pair of rose-colored glasses, the window also enhances the colors in the landscape, particularly the blue sky. Representing her intense personal experience, Norris Webb's meandering paths of travel and grief resulted in photographs that serve as meditations on life, death, home, and family.

Rebecca Norris Webb, *Ghost Mountain*, 2009

Victoria Sambunaris (American, b. 1964) has traveled the American landscape for over a decade, crisscrossing the highways that lead through truck stops, quarries, and national parks. Often, the scenes portrayed are vast, even overwhelming, with any human presence minimized to a passing train or pile of pipes awaiting distribution. At other points, the land is eclipsed by a trailer park or the wall of a dam, with nature taking a backseat to the hand of man. Sambunaris's images within the national parks are pure, clean, and untouched by human existence. As such, they transport the viewer to the serene experience of virgin land. In her greater body of work, images of national parks offer a counterpoint to the industry that seems to overtake nature.

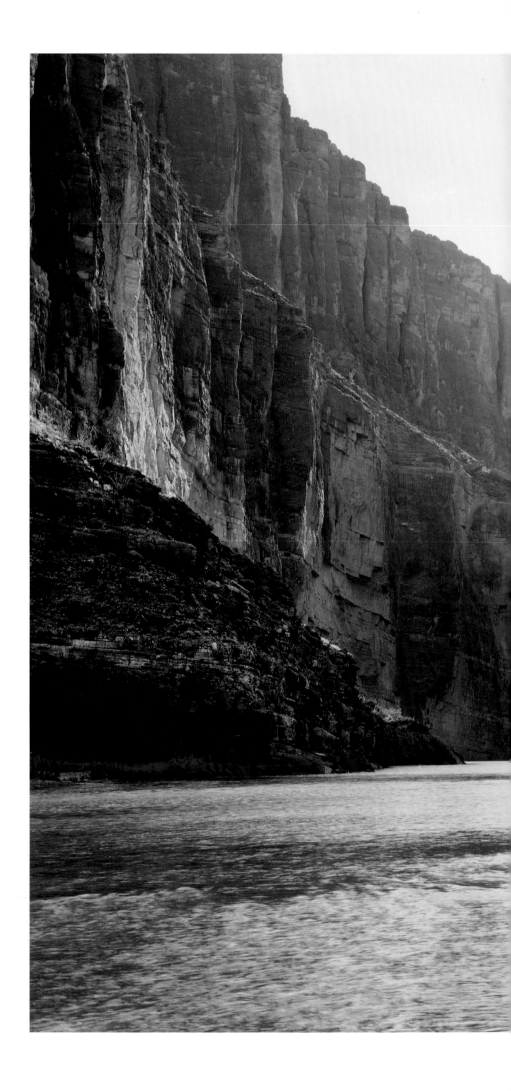

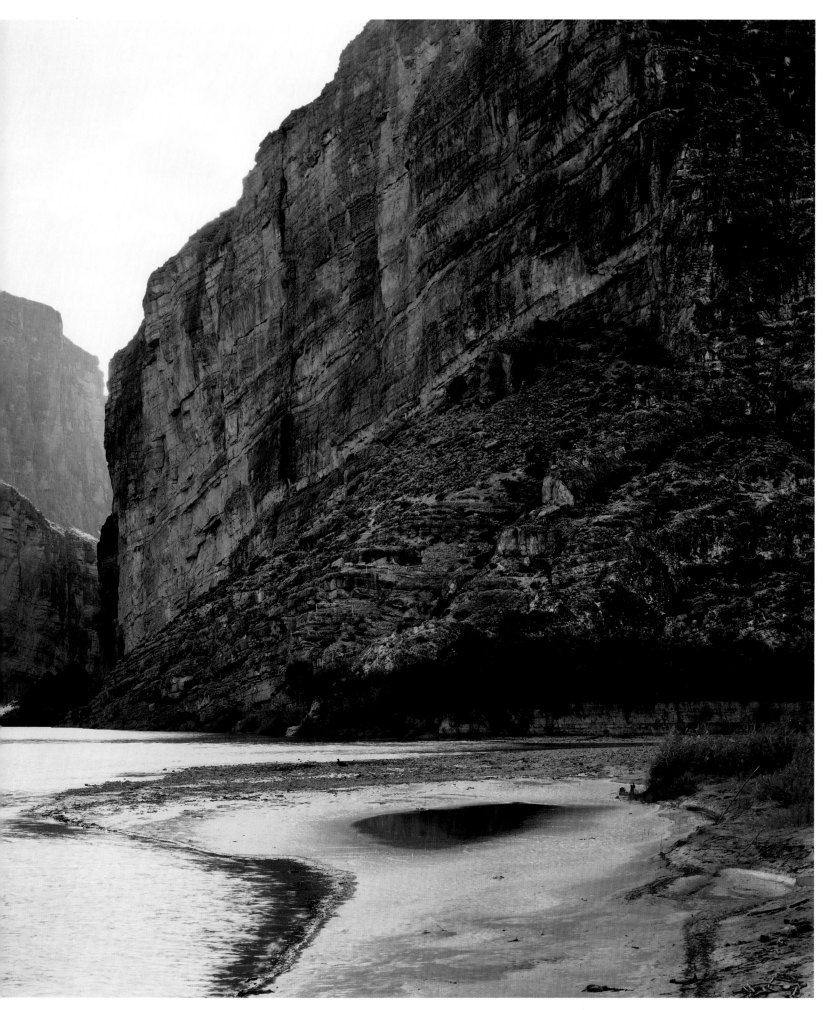

Victoria Sambunaris, *Untitled (Santa Elena Canyon), Texas*, 2010

Abelardo Morell (American, b. Cuba, 1948) employs the pre-photographic technology of the camera obscura in his tent-camera series. The tent, fitted with optics similar to that of a periscope, allows for a subject to be projected on the ground inside the structure. Morell then uses a digital camera to capture the projection. The resulting photographs are a mix of image and texture. The image is that of a common scenic view; the texture, however, is derived from the land itself, the very spot where one stands to experience the scenery. The ground cover—dirt, rocks, grass, and sand—typically lies humbly at the onlooker's feet, ignored in favor of the vista. Morell conversely ties the ground to the scenic view, transforming the geology of the landscape into his canvas. Like updated geological explorations, Morell's images layer the literal manifestation of time (the ground) with the historic views that have come to represent these iconic landscapes.

Abelardo Morell, *Tent-Camera Image on Ground: View of Old Faithful Geyser, Yellowstone National Park, Wyoming*, 2011

2011

2011

It is estimated that over 380 billion photographs are made in 2011.

Over four hundred Guggenheim Fellowships have been awarded in the field of photography since 1937.

2012

There are over 6 billion photographs on Flickr and over 500 billion photographs on Facebook.

Binh Danh begins his series of daguerreotypes in Yosemite National Park.

Rebecca Norris Webb's book *My Dakota* is published.

2013

Pinnacles National Park becomes the fifty-ninth park.

2014

The National Park Service announces the Find Your Park campaign, which will engage the public through social media in order to create awareness and support for the parks.

2015

President Barack Obama announces that the name of Mount McKinley will be returned to Denali, the name given to it by one of the Native American tribes that live in Alaska.

2016

The National Park Service turns one hundred.

2016

Abelardo Morell, *Tent-Camera Image on Ground: View of Jordan Pond and the Bubble Mountains, Acadia National Park, Maine,* March 2010

National parks require caretakers, which is in reality a twofold job. While the employees and volunteers are responsible for providing services that make guests welcome, they are also charged with preserving the spaces for generations to come. The everyday lives of these workers include tasks such as cleaning buildings, fixing trails, taking tolls at the front gate, and serving gift shops and restaurants. Yet these workers have the unique experience of inhabiting the places that others visit only on vacation. **Michael Matthew Woodlee**'s (American, b. 1984) photographs depict an insider perspective, sharing not only the working spaces of the employees but also their living environments and places of enjoyment. Woodlee's images reveal a side of Yosemite that is exceedingly ordinary, as if it is just another common campground. One might even forget that a sweeping, natural vista is perhaps just outside the frame, prompting the viewer to wonder if the workers experience the same phenomenon, inattentive to the beauty that surrounds them as they go about their day-to-day tasks to preserve it.

Michael Matthew Woodlee, *Gary on Break, Vogelsang High Sierra Camp*, 2013; from the series Yos-E-Mite

Michael Matthew Woodlee, *Claire, Chipmunk Researcher, Vogelsang High Sierra Camp*, 2013; from the series Yos-E-Mite

Michael Matthew Woodlee, *Jay Sunbathing, Vogelsang, High Sierra Camp*, 2013; from the series Yos-E-Mite

Michael Matthew Woodlee, *Chris, Campground Ranger, Tuolumne Meadows Campground*, 2014; from the series Yos-E-Mite

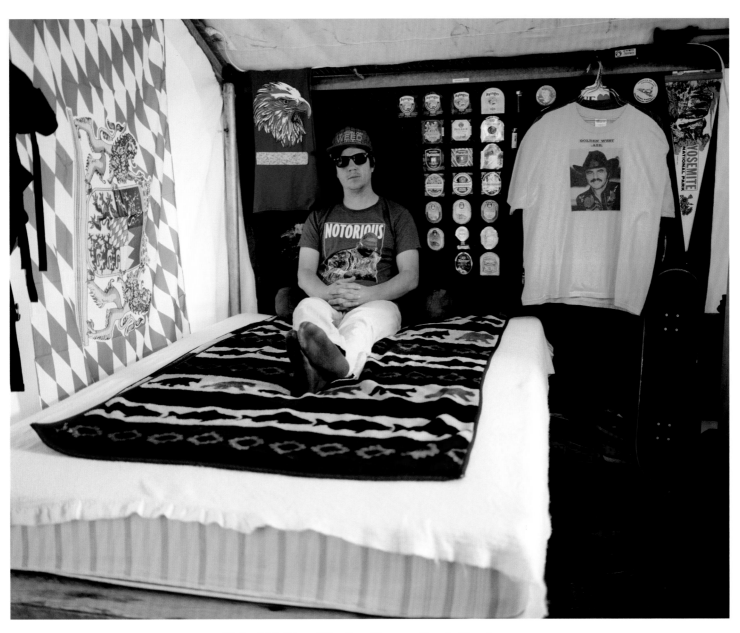

Michael Matthew Woodlee, *Gary on Break, Vogelsgang High Sierra Camp*, 2013; from the series Yos-E-Mite

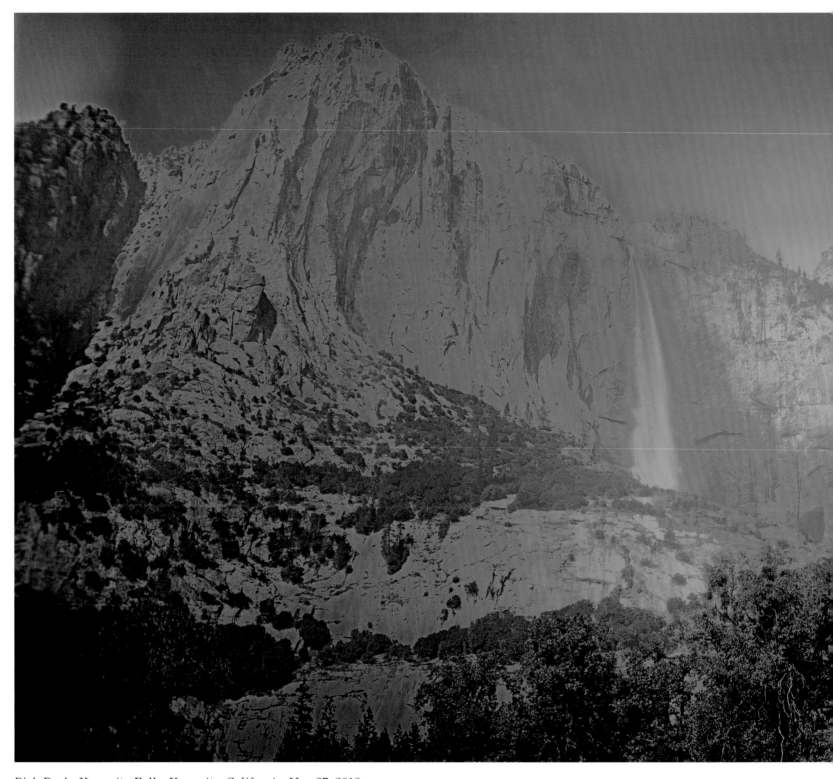

Binh Danh, *Yosemite Falls, Yosemite, California*, May 27, 2012

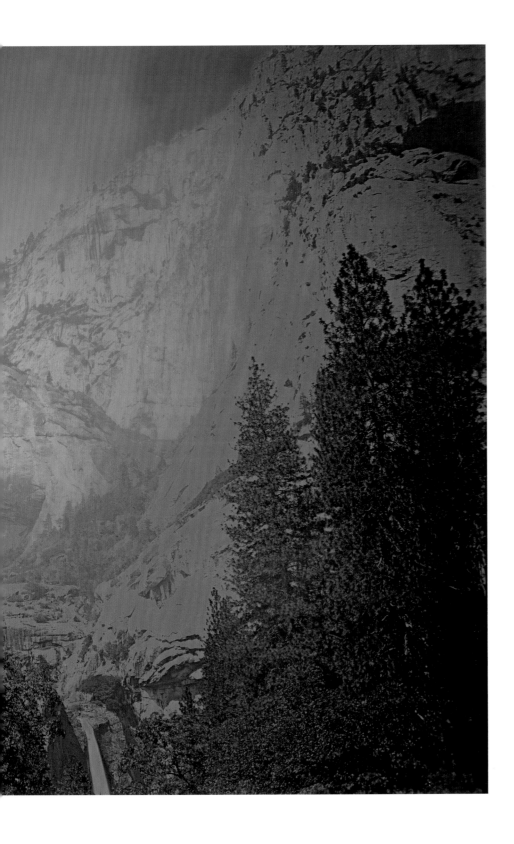

Binh Danh was born in Vietnam in 1977, fleeing the country at the age of two with his family, who eventually settled in Northern California. In 2012, Danh turned his attention to Yosemite National Park, a landscape he had never visited but was familiar with through the work of Carleton Watkins and Ansel Adams, as well as through snapshots and advertisements. On his first visit, he drove his van to the park, equipped with everything needed to make daguerreotypes, ready to use this historic process to photograph the historic landscape. The photographs he took there made the place "real" for him; it no longer existed only in his imagination and in the mythical photographs of other photographers—it was now a scene of his own making. For Danh, the daguerreotype plate encourages self-reflection, as viewers are forced to contemplate their own reflection in the mirrored surface. Danh considers the layering of his own visage on the landscape as a way to connect to his heritage as an immigrant who was raised primarily in America. When viewers observe these photographs, they too must confront their own relationship to the land. As the parks have come to represent America itself, however, the relationship is less about the historic landscape and more about what it means to be American.

David Benjamin Sherry's (American, b. 1981) photograph *Sunrise on Mesquite Flat Dunes, Death Valley, California* (2013), seems all too familiar. It brings to mind Edward Weston's photographs of Death Valley, and Minor White's ability to abstract landscapes into pure form and emotion. This feeling of déjà vu is purposeful on Sherry's part, as he reimages classic black-and-white views with a wash of monochromatic color. By rephotographing vistas that have become emblems of American national identity and applying a dizzying hue, Sherry sends our sense of reality into a tailspin. For him, this experience parallels that of coming out as a gay man, as he established his own queer gaze in a world full of expectations, conventions, and standards that do not always align with his own. In addition to taking photographs, Sherry also reads poetry and writes while visiting a park. After returning to his darkroom, he translates these highly subjective passages into visceral color, enlivening the landscape with his personal sensations and experiences. The resulting images call upon the lineage of earlier landscape photographers, yet Sherry's work sets his own unique journey apart from others.

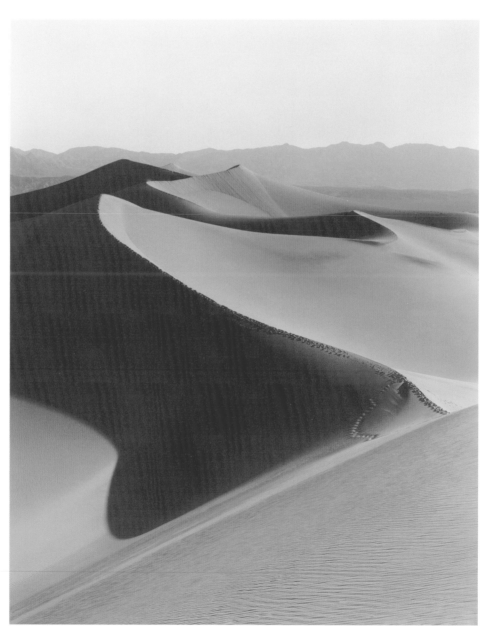

David Benjamin Sherry, *Sunrise on Mesquite Flat Dunes, Death Valley, California*, 2013

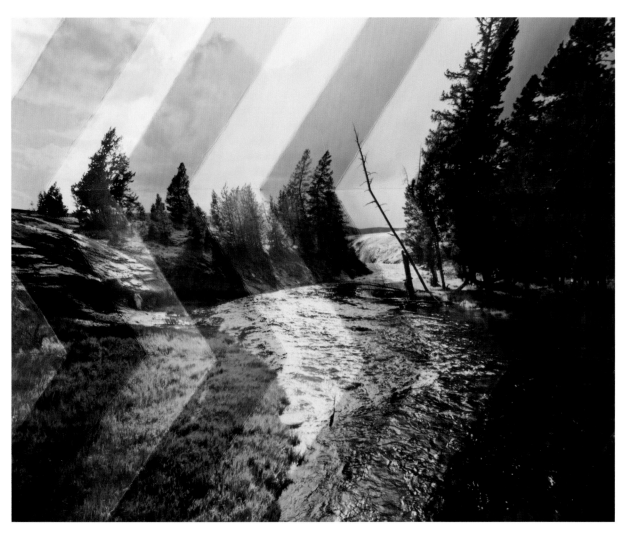

Millee Tibbs, *Mountains + Valleys (Yellowstone #2)*, 2013–15

In her series Mountains + Valleys, **Millee Tibbs** (American, b. 1976) photographs the landscape, then folds the print and rephotographs it to create the final image. The geometry of the folds is applied over her representation of a natural landscape, much like the folds of a map. While Tibbs's work emphasizes forms that naturally occur (a mountain peak, the gentle bend of a river), it also comments on the traditional compositions used throughout the history of landscape photography. In *Mountains + Valleys: Yellowstone #2*, the S-curve of the tall trees, flowing river, and shoreline is exaggerated by the double-arrow fold. By distorting our view, Tibbs calls attention to how previous generations of photographers have framed the landscape, drawing viewers into the beauty of the space but also leaving out the lesser, liminal areas found within these historic parks.

The National Park Service recently started a campaign to gather images through social media, using the hashtag **#findyourpark**. Sifting through these photographs, one finds the classic views: Yosemite Valley from Wawona Tunnel, the Grand Tetons from the road, sequoia trees close-up, dramatic views from the rim of the Grand Canyon, and crowds of onlookers watching Old Faithful shoot into the air. These are the vantages that have been established over the 150-year photographic history of the parks, now personalized as users post self-portraits or comment on their journeys to the sites. Whether portrait or landscape, the images express a keen desire to prove that we were there, experiencing the place. With social media, we now share these experiences over the Internet, making our private experiences public. The photographs become part of a bank of collective memories, in some ways subverting our need to travel to each park, but mostly urging us onward to explore them in person.

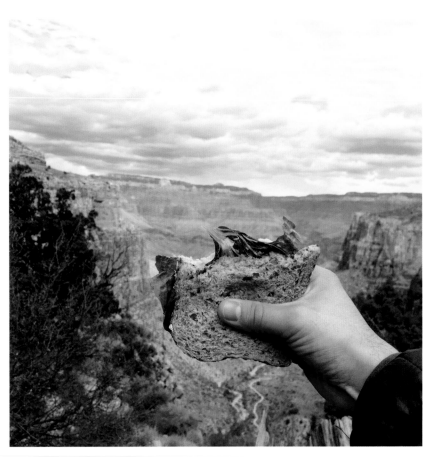

Jeremy Friedland (@jsfried), *Adventure Sandwich, Grand Canyon National Park*, 2015

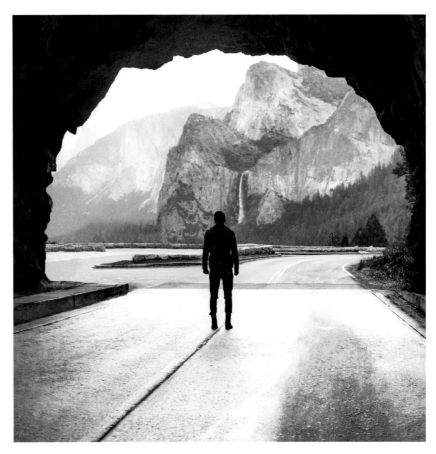

Caleb Jordan Lee (@calebjordanlee), *Tunnel View,*
Yosemite National Park, 2015

Kirsten Miles (@kirstenlael), *Untitled, Petrified Forest*
National Park, 2015

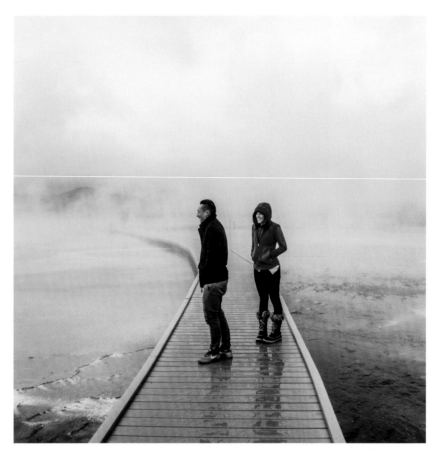

Mike Sanders (@mikejr4), *Prismatic Morning, Yellowstone National Park*, 2015

Jennifer Tousey (@jentouseymakeup), *Family Tree, Yosemite National Park*, 2015

Mabelle Theresa Denuna (@mabelletheresa), *#AdventuresOfMabelle*,
Zion National Park, 2015

Matt Davis (@matthewjdavis88), *Looking Into Zion*,
Zion National Park, 2015

Acknowledgments

A book of this scope does not come together from the work of just one individual, and I am thankful to the community that surrounds me for their assistance with this project and encouragement. With my true gratitude, I would like to acknowledge the following people for their support and contributions:

Denise Wolff, my partner on this project, who showed unfailing exuberance and continuous patience, and whose ideas shed new light on what this book could be. To Betsy Stepina Zinn for her work on the text; Fraser Muggeridge and Rachel Treliving at Fraser Muggeridge studio for the terrific design; Nicole Moulaison and Thomas Bollier for their work on production; Susan Ciccotti and Madeline Coleman for their proofreading; and Jonathan Knight-Newhall and David Arkin for gathering the permissions and tracking all the details.

My colleagues who served as supporters, sounding boards, researchers, cataloguers, editors, and so much more, and without whom this project could not have been completed: Bruce Barnes, Lisa Hostetler, Heather Shannon, Ross Knapper, William Green, Elizabeth Chiang, Rachel Andrews, Virginia Dodier, Deborah Mohr, Barbara Galasso, Taina Meller, Zach Long, Emily Phoenix, Nick Marshall, Kathy Connor, Jesse Peers, Todd Gustavson, Paolo Cherchi Usai, Jared Case, Daniela Currò, and Sophia Lorent.

My research assistants, who dutifully gathered wonderful tidbits of information: Kerry Jeyschune, Andrew Murphy, Allison Parssi, and Naharin Shech.

My family, who are my constant champions and whom I love dearly: Alice Carver-Kubik; Robert and Denise Allen; Keith, Nicolas, and Jerod Allen; Kevin and Erica Allen; John, Nora, Eleanor, and Annalise Ryszka; Ann Carver; and Matthew and Sharon Kubik. To my friends, of whom there are too many to list, but who drag me away from projects and keep me human.

The photographers, collectors, estates, and galleries that contributed photographs to this book. For their insight and advice, special thanks to Peter J. Cohen; Mark Klett and Byron Wolfe; Sean McFarland; John Pfahl; Len Jenshel; Marion Belanger; Abelardo Morell, Edwynn Houk Gallery and Jillian Freyer; Michael Matthew Woodlee; Binh Danh and Haines Gallery; David Benjamin Sherry and Salon 94; Millee Tibbs; and all of the Instagram photographers who provided images for the book.
—Jamie M. Allen

Picturing America's National Parks
By Jamie M. Allen

Front and back cover:
Herbert Archer and John Hood, *Cowboys in Grand Tetons, Wyoming*, 1964

Editor: Denise Wolff
Design: Fraser Muggeridge studio
Production Director: Nicole Moulaison
Production Manager: Thomas Bollier
Assistant Editor: Jonathan Knight Newhall
Copy Editor: Betsy Stepina Zinn
Senior Text Editor: Susan Ciccotti
Proofreader: Madeline Coleman
Work Scholars: David Arkin, Sophie Klafter, and Cassidy Paul

Additional staff of the Aperture book program includes: Chris Boot, Executive Director; Sarah McNear, Deputy Director; Lesley A. Martin, Creative Director; Kellie McLaughlin, Director of Sales and Marketing; Richard Gregg, Sales Director, Books; Amelia Lang, Managing Editor; Samantha Marlow, Assistant Editor; Katie Clifford, Project Editor and Executive Assistant; Taia Kwinter, Assistant to the Managing Editor

Picturing America's National Parks is copublished with the George Eastman Museum in Rochester, New York, on the occasion of the exhibition *Photography and America's National Parks*, on view June 4 to October 2, 2016.

GEORGE EASTMAN MUSEUM

First edition
Printed in China
10 9 8 7 6 5 4 3 2 1

Library of Congress Control Number:
2015953487
ISBN 978-1-59711-356-4

To order Aperture books, contact:
212-946-7154
orders@aperture.org

For information about Aperture trade distribution worldwide, visit:
www.aperture.org/distribution

aperture

Aperture Foundation
547 West 27th Street, 4th Floor
New York, N.Y. 10001
www.aperture.org

Aperture, a not-for-profit foundation, connects the photo community and its audiences with the most inspiring work, the sharpest ideas, and with each other—in print, in person, and online.

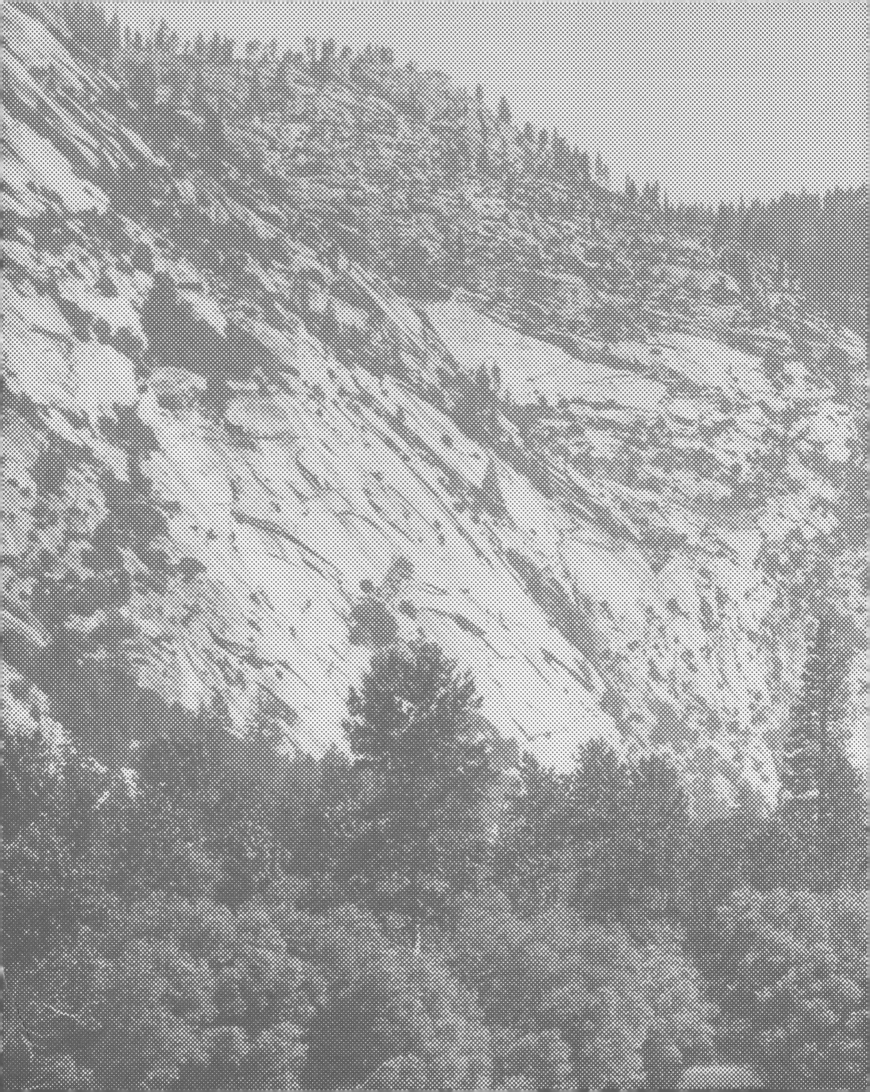

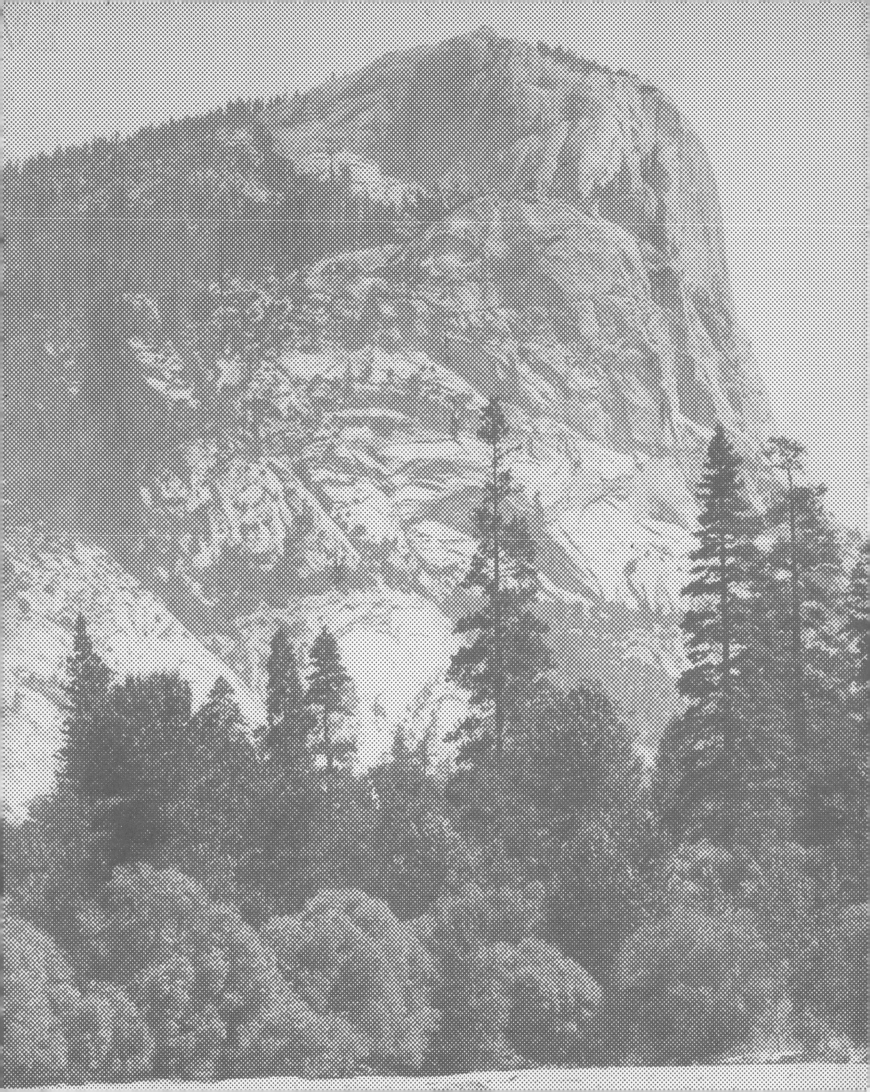